3 1000 00156289 4

NOV 1999

W9-BLH-846

How To Photograph Water

Water

Heather Angel

STACKPOLE
BOOKS

0 11557 02461 6

Copyright © 1999 by Heather Angel

Published by
STACKPOLE BOOKS
5067 Ritter Road
Mechanicsburg, PA 17055
www.stackpolebooks.com

All rights reserved, including the right to reproduce this book or
portions thereof in any form or by any means, electronic or
mechanical, including photocopying, recording, or by any
information storage and retrieval system, without permission in
writing from the publisher. All inquiries should be addressed to
Stackpole Books, 5067 Ritter Road, Mechanicsburg, PA 17055.

Printed in China

First edition

10 9 8 7 6 5 4 3 2 1

Cover design by Wendy Reynolds

Author's note: Captions with (C)
denote that the animal was captive-bred.

Cover photo: Base of Svartifoss, a waterfall in Skaftafell
National Park, Iceland.

Photo, page iv: Raindrops on gerbera petals, Surrey, UK.

Library of Congress Cataloging-in-Publication Data

Angel. Heather
 How to photograph water / Heather Angel.
 p. cm.
 Includes bibliographical references.
 ISBN 0-8117-2461-1 (pbk.)
 1. Photography of water. I. Title.
TR670.A543 1999
778.9955146—dc21 98-53196
 CIP

BELLEVILLE PUBLIC LIBRARY

CONTENTS

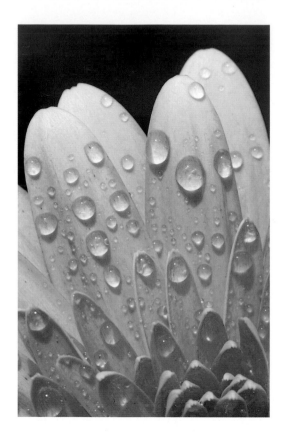

ACKNOWLEDGMENTS

The superb quality of the color printing in my companion volume, *How to Photograph Flowers,* inspired me to suggest another title for this series. I am most grateful to Mark Allison at Stackpole Books for embracing this idea with such enthusiasm.

The pictures for this book were taken in water and on land, sea, ice, and snow. Some were in my own garden, but many involved trips to far-flung locations. Though some pictures were incidental to my main objective, many came about after a great deal of preparation, planning, and not least, traveling.

To all the people who assisted me in my travels, answered my queries, and provided technical information, as well as the companies that lent me equipment, I extend my grateful thanks. In particular, I should like to thank Animals of Montana, Dr. Akira Aoki; Arctic Experience Limited; Dr. Bill Ballantine; Marek Borkowski; British Petroleum; Discover the World; Ron Eastman; Michelle Gilders; Hasselblad (UK) Limited; Joseph Van Os Photo Safaris; Kodak Limited; Trevor Lindegge; the National Trust; Nikon UK Limited; Occidor Adventure Tours Limited; the Royal Botanic Gardens, Kew; Dave Slater; Gatat Sudarto; Wilderness Safaris; The Wildfowl and Wetlands Trust; Workshops in the West; and Zegrahm Expeditions.

Special thanks go to Colour Processing Laboratories at Reading, England, for their reliable processing; Valerie West, who converted my handwritten script into the final manuscript; and Lindsay Bamford, my photo librarian, who helped me select the final images. My son, Giles, gave invaluable help in so many ways, driving me around Iceland, helping to edit and mount many films, and discussing—often late into the night—why some images worked better than others to make editorial points. Not least, for his unique contribution of a beautiful waterfall print, which appears on page 8. My husband, Martin Angel, while having to contend with our both departing abroad and debating photographic topics ad nauseam, was—as always—wonderfully supportive. Jon Rounds at Stackpole was also tremendously helpful throughout the entire production.

INTRODUCTION

For centuries, water has inspired artists, poets, writers, and more recently, photographers by igniting their creative talents. But water is much more than a source of inspiration. It is essential for life on earth. Even though desert life is adapted to survive months, even years, without a drop of water, this life-giving liquid is the vital trigger for dormant seeds to germinate and for frogs to emerge from their estivation. Yet too much water can wreck havoc on the landscape, with floods submerging terrestrial habitats and associated life, raging torrents eroding riverbanks, or tidal waves and tsunamis devastating coastal regions.

For as long as I can remember, water has always fascinated me, from my early days as a toddler paddling in the shallows on a sandy shore to the time I worked as a marine biologist, when I became a fanatical scuba diver. Later, when I took up photography, I began to appreciate the magical qualities of water.

Who can fail to be moved as the color of still water changes, not only with the time of day but also with the seasons? Calm water mirrors the sky, plants, and trees, as well as resident animals and wildlife visitors that come to drink at the water's edge. Moving water enriches the environment by adding another dimension; whether it be the splashy gurgles of a babbling brook or the raging torrent of a waterfall, the sound of unseen moving water has an instant magnetic attraction, seducing one to seek out the source.

With the exception of desert regions, water in some form or other—unlike each species of flowers, fungi, or insects, which appear for only a limited time—is readily available for photography. Seawater, which covers more than 70 percent of the earth's surface, is always present, although during the polar winters, it changes from the liquid to the solid state. Even in tropical regions, which experience distinct wet and dry seasons, life-giving fresh water is still present during the dry season in springs and larger lakes or rivers, albeit with a reduced volume.

Many books have been written about water, but this may well be the first one devoted to how to photograph it. I find this surprising, since water has such universal appeal and offers such limitless scope to the photographer, in the form of landscapes, abstracts, close-ups, and life associated with water. Whatever time of year, there is always some place where water lures the eye and fuels the creative instinct. I know that I shall never tire from the delights of working with water. Every time I venture outside, whether on a trip down a local lane or a long journey to the other side of the globe, water rarely fails to inspire me to set up my camera.

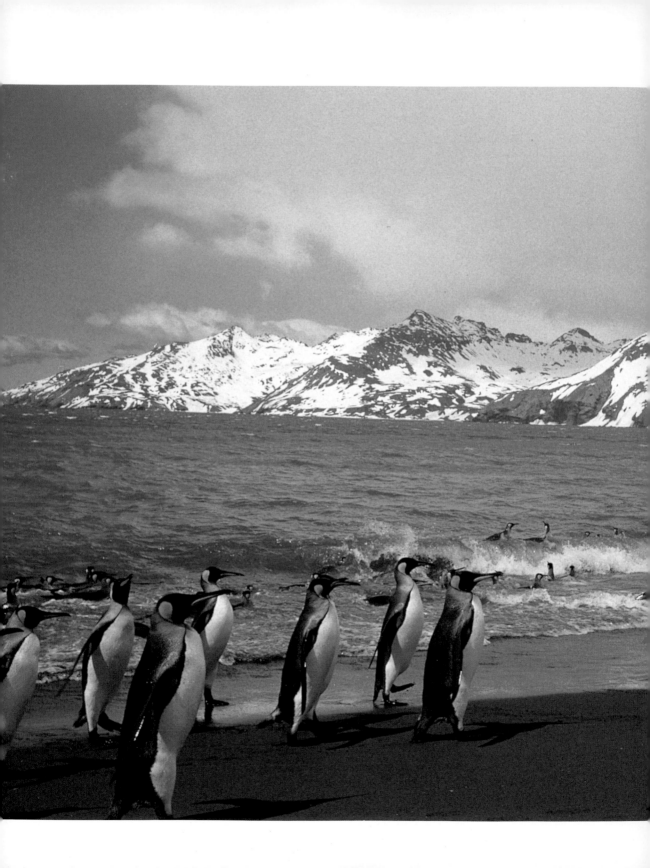

The fact that the images selected to illustrate this book were taken in twenty-two countries and span more than two decades verifies the global distribution and timeless quality of water.

Many people take pictures only as they see them; others are able to visualize an image in the mind. Either way, there are two stages in producing a photograph, whatever the subject matter. First the image is seen or conceived, then it is taken by exposing the film. The interval between the first and the second stages may be a fleeting moment or may extend to minutes, hours—even days.

Photography is very subjective. All I can do is throw some ideas to the wind, which anyone is welcome to catch, discard, or modify. If I can ease the actual picture-taking process with tips and hints gleaned from my own work, so much the better.

King penguins *(Aptenodytes patagonica)*, St. Andrew's Bay, South Georgia, Southern Ocean, November. *Nikon F4, 35–70mm f/2.8 lens, Kodachrome 200.*

The spectacular snow-capped peaks and glaciers, together with the vast king penguin rookeries, make South Georgia a special place. Here, the most enigmatic of all penguins are shown against a backdrop with water in all three states: clouds, snow, and seawater.

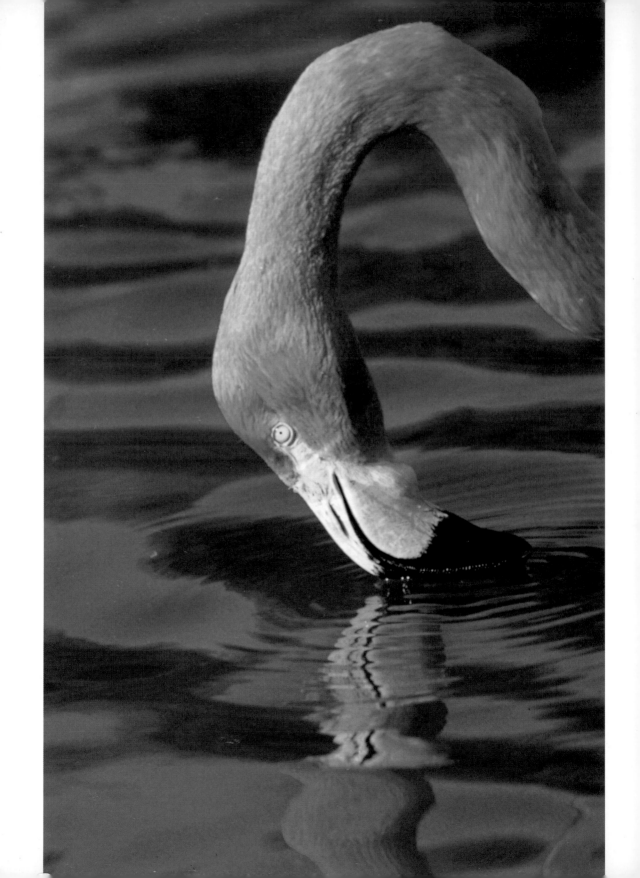

The Magic of Water

Water, more than any other substance, not only offers infinite variety to the photographer but also has universal appeal. To prove this point, you only have to look through nature engagement diaries. Invariably, at least half of the images depict water, snow or ice, or life associated with water or ice. Because of the ageless quality of water, the love of and demand for photographs portraying water are unlikely to diminish, whether they be evocative moody waterscapes for calendars and cards or simple concepts, such as ripples on a pond or a gigantic wall of water breaking on a surfing beach, which are so appealing to advertising markets.

No other medium covers more of the earth's surface than water, even though the opportunities for taking exciting images of vast water areas such as large lakes or huge oceans are limited. Much greater potential can be found at the interface of water and land or at smaller water bodies such as springs and creeks, pools and puddles, swamps and marshes, streams and

rivers, waterfalls and cascades, or even tide pools and salt pans.

Water may be found in three states: liquid, vapor, or solid. Wet, dripping, calm, choppy, and turbulent are adjectives that describe the liquid phase. But if we consider water as a vapor, then damp, humid, foggy, or misty are more appropriate, whereas chilly, nippy, freezing, frigid, arctic, or glacial apply to ice, snow, and frost, the solid phase of water.

It is quite possible to illustrate all three phases in a single picture. A snow-capped mountain can form a backdrop to a lake or river, with clouds set against a blue sky. During winter within a thermal region in temperate latitudes, such as Yellowstone National Park, large rivers flow past snow-covered ground while steam rises from nearby geysers.

Capturing the quintessential qualities of all three phases with optimum lighting within a single picture may not be easy. Sometimes it is better to concentrate on one or two phases. Once the prime viewpoint has been selected, the best time of day needs to be considered. After this, decisions have to be made as to which lens, which film, which shutter speed, and which aperture to use. All too rarely do all the variables come together to produce a perfect image. We all have experienced situations where the location is perfect but the lighting far

Reflection of greater flamingo *(Phoenicopterus ruber)* filter feeding, Wildfowl and Wetlands Trust, Slimbridge, Gloucestershire, UK, March. *Nikon F4, 500mm f/4 lens, Ektachrome 100S.*

1

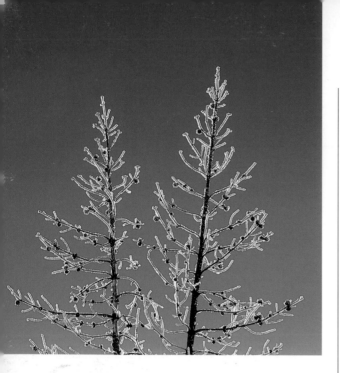

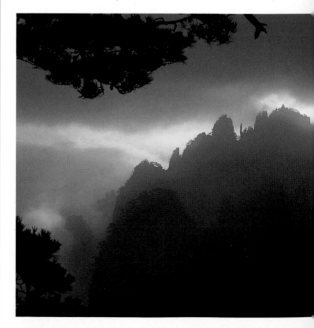

atmosphere, depending on the temperature, it falls to earth as water, hail, or snow. Sooner or later, water drains into streams and rivers or collects in underground aquifers, ultimately making its way to the sea. The cycle is completed when water is returned to the atmosphere by evaporation from the leaves of green plants and from water bodies.

Water—still or moving—adds an uplifting dimension to many a landscape. A small area within a scenic shot can provide a contrasting tone or color. Whitewater cascading over the lip of a fall or flowing over a rocky

Ice-covered dead lodgepole pines *(Pinus contorta),* Yellowstone National Park, Wyoming, January. *Hasselblad 500 C/M, 150mm f/4 Sonnar lens, Ektachrome 100 Lumière with polarizing filter.*

In thermal areas where fumaroles steam constantly and air temperatures plummet at night, dramatic ice-coated scenes develop. The steam rapidly cools in the freezing air and overnight transforms gaunt tree skeletons killed by the 1988 fires into fantastical ice trees. On cloudy days, with temperatures below freezing, the ice may persist all day. But once the sun breaks through, the magical scene is destroyed as icy shards fall from the trees sparkling in the sunlight.

Sun breaking through clouds, Huang Shan, Anui Province, China, October. *Nikon F4, 35–70mm f/2.8 lens, Kodachrome 25.*

Not until I visited Huang Shan did I realize that many of the Chinese ink brush scenes depicting precipitous slopes with wizened trees actually exist in nature. My guide woke me while it was still dark so we could reach a viewpoint before the sun rose. The silhouetted foreground pine trees serve to frame the distant peaks and sunlit clouds.

from ideal or vice versa. More than once I have retraced my tracks in the hope of gaining a better viewpoint, improved light, or less wind.

Every outdoor photographer is all too aware of the fickle nature of weather, never more so than when appraising possible water shots, since the relative abundance of water is inextricably linked with the water cycle. As water vapor condenses in the

stream or riverbed can help lighten an otherwise somber scene, and a colorful sky can help uplift the dreariest of wetland vistas. More than once I have seen a low-angled winter sun break through to transform nondescript water into navy blue pools fringed by grass turned golden by winter frosts.

Indeed, it is hard to ignore any colorful reflection in calm water, whether it be a sunrise or sunset, autumn trees bedecked in fiery colors, or a kaleidoscope of flowers. At such times, if a fish should happen to rise, radiating ripples can add a dynamic dimension to the reflected colors. If there is no obliging fish—providing you are not a purist—a pebble thrown into the water will also produce ripples. But if you want crisp images of submerged plants or aquatic life, the surface needs to be calm and ripple-free, as any disturbance will distort natural shapes into abstract forms. If the wind is blowing or fish are rising, you may have to change your objective and go for creative images or else pack up until later.

Animals that live permanently in water or make frequent forays to water to feed, drink, or roost can be challenging subjects because they are constantly on the move. Spend time researching an area by calling local rangers or talking to naturalists or other photographers to find out where to start searching and reduce your downtime.

Icebergs, like birds in wetlands, are predictable in certain locations at specific times of year. The exciting thing about icebergs is the variation of both shape and color so that no two are ever identical. Within a single day, the color of a berg can change due to direct versus indirect sunlight, rain, or a dry atmosphere. Blue icebergs are especially stunning, but when bathed with an ephemeral pink or golden glow, white bergs develop a special luminosity of their own.

Water lilies, together with the sacred lotus, have to be among the most photo-

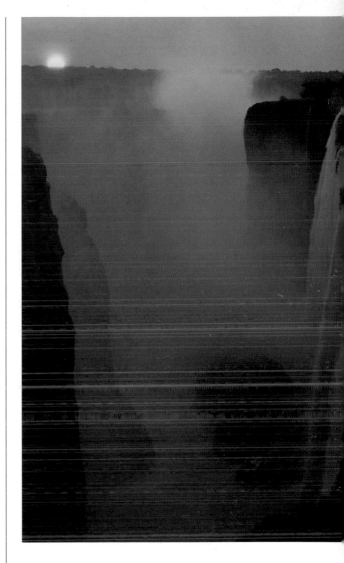

Sun setting behind Victoria Falls, Zambia, September. *Nikon F3, 80–200mm f/2.8 lens, Kodachrome 25.*

For this sunset shot of Victoria Falls, I crossed the Zambezi River to the Zambian side (see page 63 for another view). Because the contrast between the white curtain and the dark rocks is so great in sunlight, I waited until the canyon interior was lit with the last rays of sunlight. Filtering through the spray, this produced a wonderful atmospheric picture before the sun dipped below the horizon.

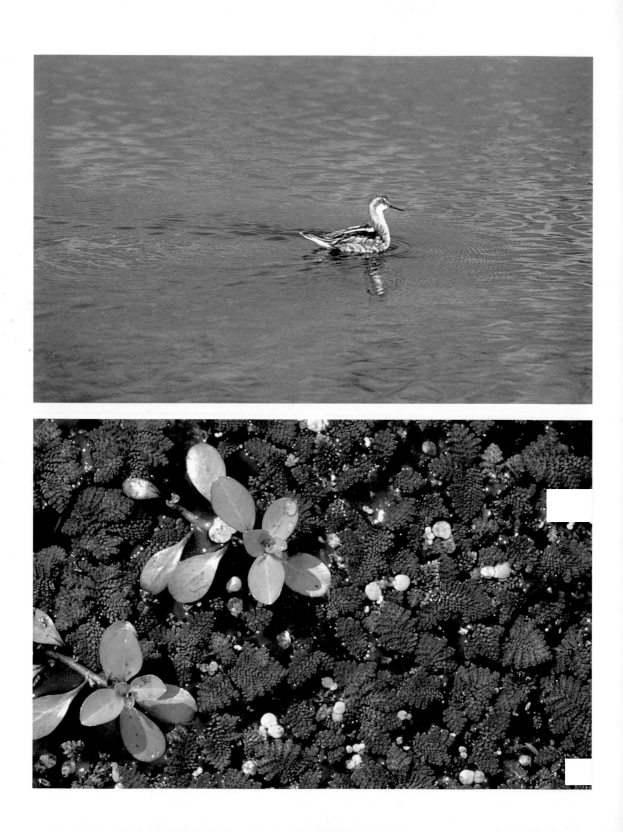

Top left: Red-necked phalarope *(Phalaropus lobatus)* in lake at Søndre Strømfjord, west Greenland, July. *Nikon F4, 300mm f/4 lens, Kodachrome 200.*

With little natural cover in Greenland, I had to inch my way toward the water by belly-crawling. My mission was to get the red-necked phalarope with the exciting blue-edged wake cutting through the beige water. I exposed only a few frames before the sun disappeared behind the clouds and the phalarope swam farther around the lake.

Bottom left: Water fern *(Azolla pinnata)* floating on a pool at Duba Plains, Botswana, September. *Nikon F4, 105mm f/2.8 Micro-Nikkor lens, Ektachrome 100S.*

From a distance, this delicate fern appeared as a uniform red layer carpeting part of a pool. A macro lens reveals the intricate way the leaves overlap on each tiny plantlet. So that the whole area of the frame appeared sharply in focus, I made sure the camera back was parallel with the water. The green plants provide a color contrast that complements the red water ferns set against the dark water.

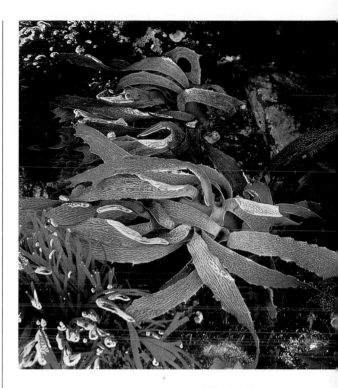

Brown alga, Goat Island Bay, North Island, New Zealand, January. *Hasselblad 500 C/M, 80mm f/2.8 Planar lens with 1.0 Proxar, Ektachrome 64.*

As the tide receded down the shore, both the color and texture of this seaweed in a rock pool caught my eye. The bright, linear skylight reflections follow the contours of portions breaking the surface and immediately convey that the seaweed is growing underwater. A continuous cloud cover produced soft, even lighting, which was ideal for this subject.

genic of all aquatic plants. Single blooms can be taken from the side or from overhead, looking down into the heart of the flower. The striking fruits of the lotus, much sought after by flower arrangers, are also worthy of a second look.

But there are a host of other water plants with colorful—albeit smaller—flowers, as well as tiny plantlets that spend their whole life floating freely on the surface. Floating leaves survive being pushed underwater by waterfowl or larger animals by having special adaptations to ensure that they rapidly rise to the surface again. For example, water lily leaves are full of cells with large air spaces that make them buoyant and have a thick, waxy outer layer that ensures

water easily drains away. Miniature runnels in the leaves facilitate rapid water runoff.

Animals that frequent ponds or lakes aid the dispersal of water plants to other water bodies. When birds alight on muddy margins, they transfer seeds on their feet. I have seen duckweed-covered toads walking along a towpath after crawling from a canal, and

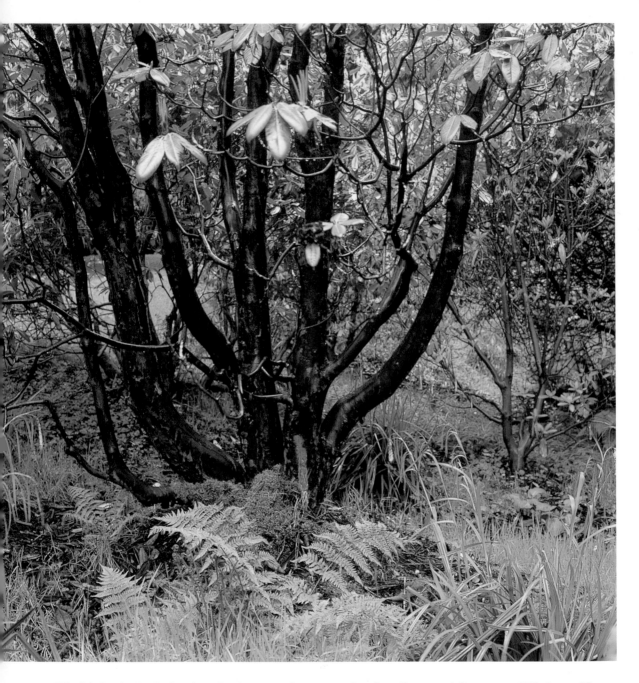

Wet bark of *Rhododendron barbatum* at Inverewe Garden, Ross and Cromarty, UK, June. *Hasselblad 500 C/M 80mm f/2.8 Planar lens, Ektachrome 100 Plus Professional.*

The bark of some shrubs and trees is transformed when wet by rain. Within minutes after the rain began to fall, the pallid bark—still visible at the base of this rhododendron—began to shine out from the surrounding plants.

even a hippopotamus walking on land carrying entire water lettuce plants on its back.

I am sure that most photographers, given the choice, would opt for photographing exquisite water lilies over seaweeds. Nevertheless, marine algae do present opportunities for some exciting—and more unusual—photographs of plants that live in water. Many large, brown seaweeds remain permanently submerged in the subtidal region, but during spectacular low spring tides, some become exposed to the air for brief periods. Therefore, the odds of stumbling upon them by chance are minimal. Some knowledge of local tides, topography of the seashore, and the degree of exposure is necessary to ensure that you visit the right place at the right time. Even then, you will have to work fast, since within an hour, the tide may turn to submerge the seaweeds again.

Raindrops on fallen oak leaves, Nottingham, UK, November. *Nikon F4, 105mm f/2.8 Micro-Nikkor lens, Ektachrome 100S.*

This picture is testimony to the way that rain can add magic to a close-up. After a morning lecture, my students were scheduled to do some practical work outside in the afternoon. As rain had set in for the day, they thought I would cancel the field trip. At first they were reluctant to take out their cameras, but after an hour, they all were excited over the rich colors of the wet, fallen leaves and the raindrops captured by slightly matte surfaces.

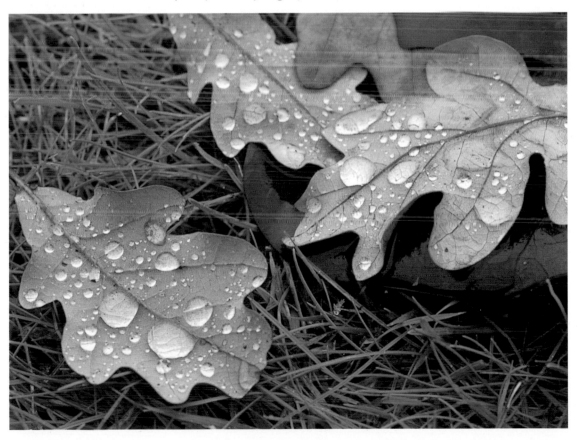

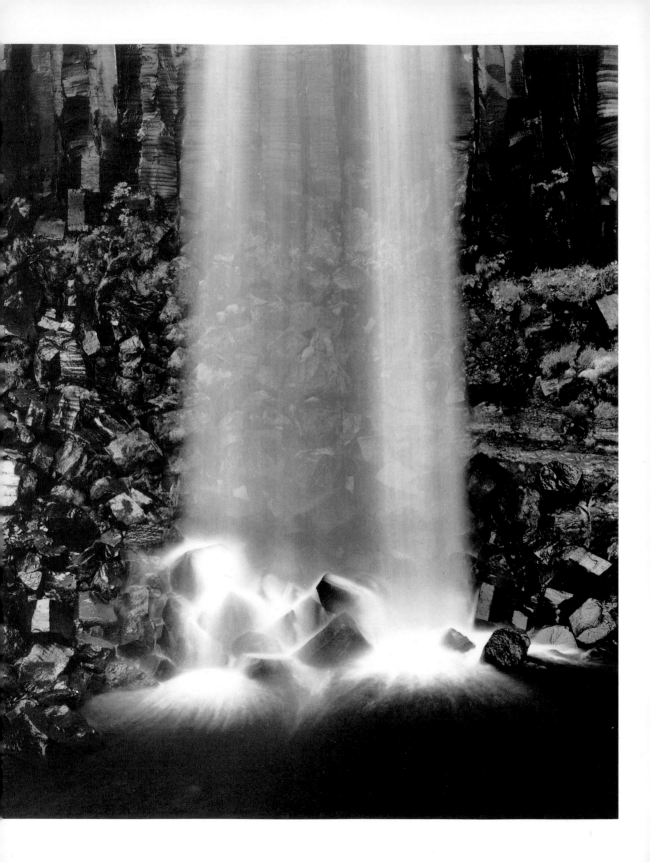

Split-toned sepia and gold print of Svarti-foss, an Icelandic waterfall, July. *Hasselblad 501 CM, 150mm f/4 Sonnar lens, Kodak T-Max 100.*

This picture, taken by Giles Angel, illustrates how black and white film can be used to produce a fine-art image. A conventional monochrome print was bleached, then immersed in sepia toner followed by gold toner. A different crop of the same waterfall, taken on color slide film seventeen years earlier, appears on page 42.

The interface of land and water presents a whole gamut of patterns and designs. Large-scale designs within a flat land-scape—such as islands in swamps, the tundra surface mosaic formed by repeated freezing and thawing, or snaking patterns of creeks in a salt marsh—become apparent from a light aircraft. At high latitudes, broad-fronted, braided rivers are a distinctive feature of glacial landscapes. Their repeatedly bifurcating structure is best appreciated either from the air or by climbing adjacent high ground.

As rain falls on a bare mud slide, it creates small runnels that enlarge as they merge into others on their downward journey, creating a dendritic pattern. Rain also helps enrich colors of plants and rocks, especially if they have become coated with dust after a dry spell. Some ornamental trees, such as the strawberry tree, are planted specifically for the vibrant color of their wet bark. Also, drab-colored pebbles come to life upon immersion in water.

More intimate wetland subjects include ripple patterns in water or on a sandy beach and the stress patterns formed as a pond or a salt pan dries out. All present opportunities for graphic wide angles or detailed close-ups. Other subjects worthy of a closer look include raindrops on leaves, dewdrops that define the delicate tracery of spider webs, and frost on fruits or leaves.

The subjects outlined above and illustrated in this chapter are merely a taste of the many delights of working with water. The scope is limitless, from taking classic representational scenics of what the eye sees to abstracting part of the scene or using false color films, such as infra red, or alternative photographic processes, such as cross-processing of color slide film with a color negative process. With one exception, all the illustrations in this book were shot on color transparency film, which is my normal working medium.

Access to a darkroom offers the opportunity to experiment in highly creative ways by using a black and white negative to produce lith or color-toned prints. When my son, Giles, accompanied me on a trip to Iceland, he chose to work in monochrome so he could produce fine-art prints for limited-edition sales.

Equipment

Cameras and Lenses

Cameras and lenses are vital tools for my work. I regard them as extensions of my eyes and hands that enable me to capture a quintessential moment.

Your choice of camera and lens will depend on the type of subject you wish to shoot, the accessibility of the location, and the price tag. Any type of camera and film format can be used to photograph water, but the most versatile for working in wilderness locations is a 35mm single-lens reflex (SLR) with a wide choice of lenses. Most of the pictures in this book were taken using such a system, with lenses ranging from 20 to 500mm. In addition, I also use a medium-format Hasselblad system.

As a guideline, I have listed various focal lengths and suggested some subjects they can be used to photograph, but there is no need to follow this slavishly. Indeed, if you have the time, it is always worth working any subject with several lenses.

Your photography will be more creative if you resist pigeonholing your lenses so that the wide angles are kept for views and the telephotos for wildlife. It is quite possible to use any lens to photograph a wide variety of subjects, although it takes a creative mind—plus a cooperative animal—to get a wildlife portrait at close range with an ultra-wide-angle lens. When confronted with a broad vista, such as a river, stream, lake, or waterfall, a long lens—300mm or more—can be invaluable for cropping the scene several different ways.

Another decision is whether to use autofocus (AF) lenses. When taking landscapes and static subjects in general, not only is an AF lens unncessary, but it can be a distinct disadvantage. Depending on the composition, you may not always want to focus in the center of the frame, as an AF lens automatically does, and even though you can use the focus lock with AF to shift the plane of focus off center, this can be a nuisance. On the other hand, when taking action wildlife pictures, AF can be an asset. Especially when an animal is running toward you, the facility of predictive AF is a great boon.

When working with wildlife in low light levels, so-called "fast" lenses, with a large

Right: Sea palm algae *(Postelsia palmaeformis),* Point Lobos, California, October. *Nikon F4, 500mm f/4 lens, Kodachrome 200.*

The surf was so powerful, I had no option but to stand well back. Without a 500mm lens, this shot would not have been possible on this particular day. As the wind was also buffeting the tripod, I had to use a fast shutter speed to prevent camera shake, so I was glad I had a medium-speed film.

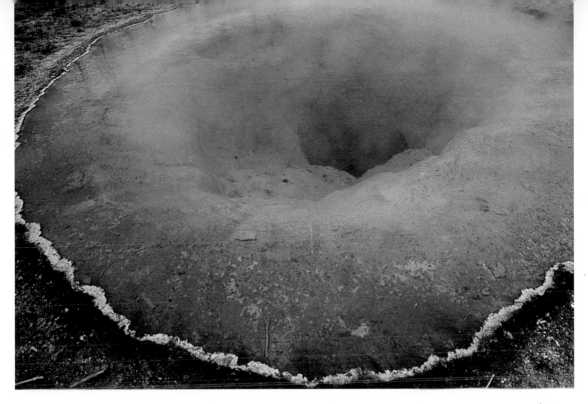

Above: Morning glory pool, Yellowstone National Park, Wyoming, January. *Nikon F4, 20mm f/2.8 lens, Ektachrome 100 Lumière.*

In areas where photography is restricted to working from raised boardwalks as a necessary safety precaution, camera angles are limited. Here, however, a 20mm lens enabled me to include virtually the whole area of the exquisitely colored hot spring without any distracting portions of the boardwalk in the shot.

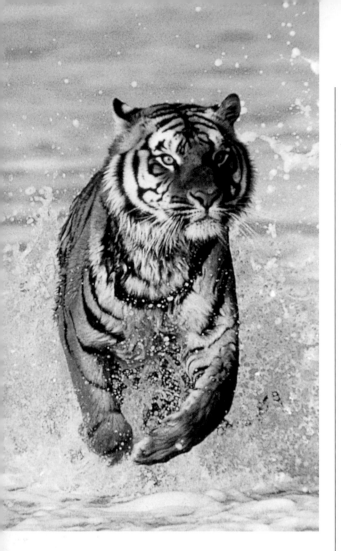

Tiger running in surf, California, November. *Nikon F4, 200–400mm f/4 lens, Kodachrome 200 (C).*

A face-on view of a tiger running in the surf can be achieved only by working with a trained animal. Even so, a long lens ensured I had a reasonable working distance between the tiger and me!

Lens focal length	Subjects
20mm	Complete arc of rainbow
24mm	Wetland sites at close range
35mm	Aquatic plants in foreground with wetland habitat behind
35–75mm	Same as above; waterfalls in the landscape; wetland and winter scenics
80–200mm	Waterfalls, mass liftoffs of waterfowl; groups of large animals in water or on snow; penguins from inflatable boat; water abstracts; abstracts of snow on hillsides
300mm	Whales from boat; portions of a landscape; water abstracts
400mm, 500mm, and 600mm	More timid wildlife in water or on snow, such as beaver, moose, or hippo; waterfowl portraits or small groups; inaccessible large water plants
105mm macro lens	Accessible water plants
200mm macro lens	Frogs and toads spawning; frost and snow close-ups

maximum aperture, such as f/2.8 300mm or f/4 500mm, will be less restrictive than slower lenses with a maximum aperture such as f/5.6, because they permit faster shutter speeds to be maintained. Fast long lenses are, however, both expensive and heavy. Lightweight mirror lenses are not the answer.

They have a fixed aperture and so cannot be stopped down. Also, any bright, out-of-focus highlights—and there are always plenty on moving water and wet surfaces—will appear in your photograph as ring doughnut shapes.

With airlines enforcing tighter restrictions on the weight of carry-on baggage, the

pros and cons of each lens have to be carefully assessed when traveling by air. Checking equipment is not necessarily a good alternative. Since all checked baggage is now X-rayed, the old ploy of using a battered bag to disguise an expensive lens is a fruitless exercise. I know of several photographers who have lost equipment that was checked—including all the contents of a locked Pelican case!

Nowadays, a single good zoom lens can substitute for two or three prime lenses. Indeed, there is a good argument for using zoom lenses when working in or near water, since this will reduce the need to frequently change prime lenses and hence the risk of dropping one in water. Also, perhaps most importantly, the ability to speedily change focal length allows for precise composition and cropping in-camera without any extraneous marginal distractions. Wherever possible, I take both horizontal and vertical shots of the same subject, which often means varying the focal length to gain a more harmonious composition. This can be done most easily with a zoom.

The downside of using zoom lenses is that they tend to be slower and therefore have a smaller maximum aperture than a prime lens, for example, f/4 or even f/5.6 instead of f/2.8, which is significant when working in poor light or when you want minimal focus to separate the subject from

the background. Also, lens hoods for zooms are invariably a compromise, especially with the shorter lenses, since to avoid vignetting when used on the widest angle, the hoods are much shorter when set at the narrowest angle than the equivalent prime lens hood. Fast zoom lenses do exist, but they tend to be pricey and quite heavy.

Macro lenses and other means of taking close-ups are covered in part 11.

Filters

All filters alter light, some in a subtle way and others to a more spectacular extent, which may bear little resemblance to the

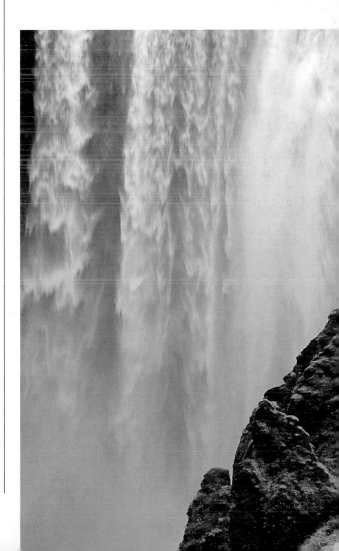

Part of curtain of Skógafoss, a waterfall in south Iceland, July. *Nikon F4, 80–200mm f/2.8 lens, Ektachrome 100S.*

Without a blue sky backdrop to this huge waterfall, the conventional face-on view was not worth taking, because it would have been white water against a white sky. Instead, I chose a tight crop on a portion of the curtain. The marginal strip of grass introduces a small area of color to a picture that works as a backdrop for overprinting text related to water.

natural world. There is now such a wide range of filters available that space will not permit me to mention more than a few here. To fully appreciate the effect each produces, and thus the most appropriate occasions to use it, study one of the highly illustrated booklets produced by the major filter manufacturers, such as Cokin, Hoya, Tiffen, or Chromatex.

Provided it is clean and scratch-free, a **haze filter** reduces blueness caused by haze and ultraviolet rays and helps protect the front lens element from dust, salt spray, and surface abrasion. It will have no effect on the overall colors, and should it become damaged, the filter will be much cheaper to replace than the lens itself.

Without any doubt, the filter I rate as most useful for working with water and wetland scenics is the **polarizer.** In addition to reducing haze, saturating blue skies so that the contrast is heightened with white clouds, erupting geysers, or snow-capped mountains, a polarizing, or pola filter can be used to eliminate distracting reflections on water. On the one hand, it can intensify the sky color reflected in water, especially with low-angled light; on the other, it clarifies the view down through the water surface for pictures of submerged aquatic plants or animals.

The effect of using such a filter can be gauged by holding it in front of the eye and rotating it. For maximum polarization of the sky, the sun needs to be beaming at right angles to the direction the camera is aimed.

There is a downside to using this filter, though, for when the reflected light is fully polarized for maximum effect, the light is

Whooper swans *(Cygnus cygnus)* and pintails *(Anas acuta)* feeding at edge of sea beginning to freeze, Hokkaido, Japan, January. *Nikon F4, 200–400mm f/4 lens, Ektachrome 100 Plus.*

A group of animals such as this gathering of waterfowl, which are intent on feeding during a short winter's day in a small area of unfrozen water, can often be taken using a medium long focus lens. The pintails were so busy upending that they barely paused to notice that I was standing at the edge of the ice.

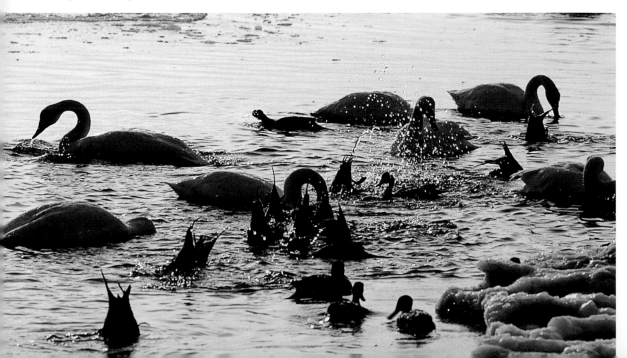

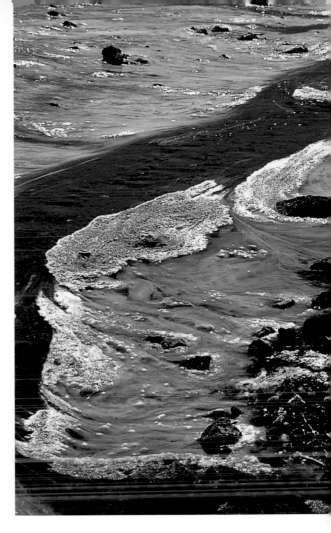

Multicolored algae in stream, south Iceland, July. *Nikon F4, 80–200mm f/2.8 lens, Ektachrome 100S.*

Above: No filter.

Right: With a polarizing filter.

This pair of pictures illustrates just how dramatic the transformation can be when a polarizing filter is used to clear the skylight reflection from water. The enriched colors of the algae, together with the juxtaposition of the black volcanic stones, were so exciting that what was intended to be a brief stop turned into a two-hour session! An abstract close-up taken at this location appears on page 115.

reduced by one and a half to one and two-thirds stops. With fast films or when taking static subjects, this is not a problem. With slow films, however, it has the same effect in terms of light loss as when using an f/4.5 lens instead of an f/2.8 lens. If a fast shutter speed is needed to stop the action of an active animal, this can be crucial. In this case, either use a faster film or "push" the nominal rating (see page 28). It is possible to reduce the light loss by partial polarization, but the beneficial effects will likewise also be reduced. On overcast days, the effect of using a polarizing filter is barely discernible and therefore not worth the time involved.

Pola filters can be either linear or circular. Linear types can create problems by causing erroneous spot meter readings, and they also affect some autofocus systems, so go for a circular pola. Make sure to remove polarizing sunglasses before looking through a pola filter.

Large-diameter fast lenses require large filters to cover the front lens element, which, in the case of a polarizing filter, can be very costly. This is why these long lenses have a

15

filter slot behind the last internal lens element to hold small-diameter drop-in filters.

The cold blue light of an overcast day can be counteracted by using a straw-colored **warming filter.** Available in different strengths, from 81, the weakest, to 81EF, the strongest, warming filters are best used for compositions that exclude the sky, since they will introduce an unrealistic color to an overcast sky. A warm graduated filter can be used upside down to warm up the foreground in cold light.

The intensity of an orange sky—and its reflection on water—can be enhanced by using a **sunset filter,** orange in color. Also available in different strengths and as graduated color, it is particularly effective when shooting silhouettes against a weakly colored sky at dawn or dusk, since it does not affect the color of the silhouette itself.

Our eyes can accommodate several stops more contrast than can color slide film. A **graduated**, or **grad filter** helps reduce the contrast—and hence the exposure difference—between a white sky and a darker landscape below. A grad filter has a colored strip at the top that gradually fades into a clear bottom. Available colors include gray and mauve, both good for overcast skies; blue, which adds realistic color to colorless bright skies; pink and sunset, suitable early or late in the day; and tobacco and magenta, decidedly unnatural colors that are much favored by art directors of car advertisement shoots. Each color is available in a range of intensities. The use of a grad filter is less unobtrusive when the horizon is level so that no color overlaps the land. It is all too obvious when the colored area affects not only a drab sky but also hilltops or mountain peaks.

Icebergs in Jökulsárlón glacial lagoon, calved from Breidamerkurjokull Glacier, Iceland, July. *Nikon F4, 35–70mm f/2.8 lens, Ektachrome 100S, with a gray graduated filter.*

I waited all day for some color to appear in the sky so I could take wide-angle landscapes. Finally, by late afternoon, I decided the only option I had was to darken the colorless sky by using a colored graduated filter. I chose gray because it looks more natural than tobacco or magenta, and with so much cloud cover, a sunset grad filter would have been inappropriate.

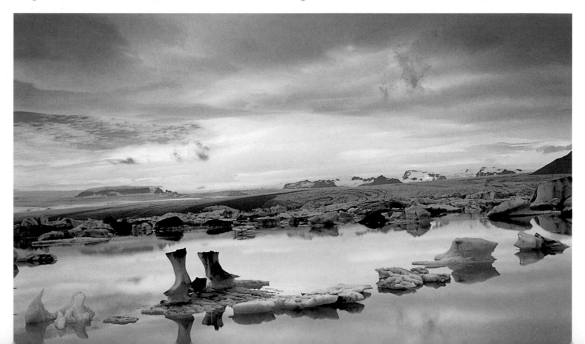

The use of other filters is discussed elsewhere, including neutral-density filters (part 6), fog filters (part 8), and rainbow spot filters (part 10).

In most cases, when photographing water in the landscape, flash is anathema. Rarely will it enhance a picture, apart from illuminating foreground objects in shadow or being used as a fill-in. Since water and wet surfaces, including ice, generally are very reflective, the angle of the flash is much more critical than when taking dry subjects, and it must be used off-camera.

Camera Supports

When working in good light with not-too-long lenses, tripods might seem an unnecessary encumbrance. But as someone who uses a tripod 99 percent of the time, I can honestly say that it serves many purposes.

Most obviously, it prevents a blurred image as a result of camera shake and allows you to use slower shutter speeds, even with long lenses. This in itself is a huge advantage, especially in poor light, but an often overlooked advantage of a tripod is that it enables you to be much more critical about the composition. After all, there is a limit to the length of time you can brace your arms to hand-hold a camera up to your eye. Taking vertical pictures also is easier, especially when using a long lens with a tripod collar.

The ideal size and weight of a tripod depends on the weight of the camera with the longest lens. Long telephoto lenses need a substantial tripod and head, whereas anyone specializing in close-ups can get away with less bulk. A flimsy tripod that moves in the slightest breeze is useless. I have used the British-made Benbo tripod for nearly all my working life, and it has never let me down, whether on a rocky shore, in a river, or on snow.

More maneuverable camera supports for taking action shots of wildlife with long

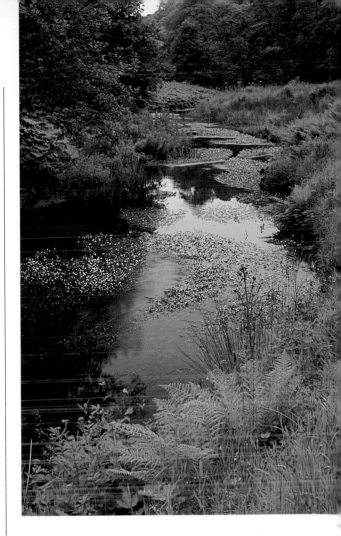

River Derwent, Forge Valley, Yorkshire, UK, June. *Nikon F4, 35–70mm f/2.8 lens, Kodachrome 25.*

Having an adaptable tripod that can be erected speedily on uneven ground can save many precious minutes in a single day. The unique design of the British-made Benbo tripod allows any leg or the center column to be rotated through 360 degrees so that the position of the legs can be adapted to the terrain.

lenses include a monopod, useful when working on boats, and a shoulder stock, or gunstock. The wooden gunstocks distributed by Leonard Rue Enterprises are substantial. Before buying one, check that it fits snugly against your body.

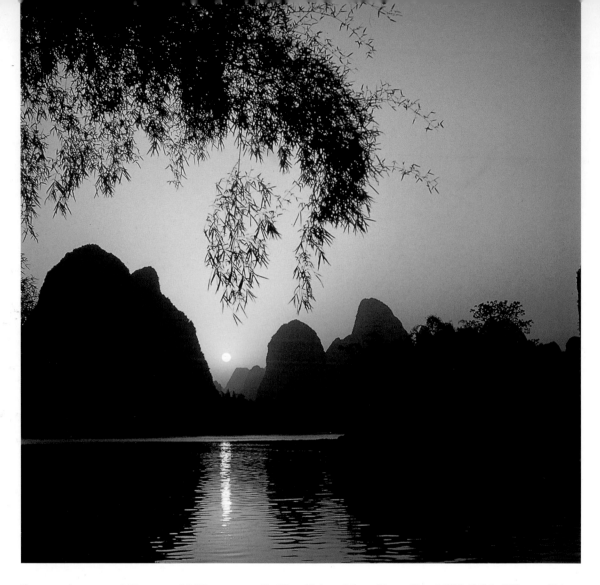

Sun setting over Lijiang or Li River near Guilin, China, May. *Hasselblad 500 C/M, 150mm f/4 Sonnar lens, Ektachrome 64.*

The Lijiang is one of the most photogenic and most photographed of all China's varied scenes. Having found the best viewpoint, I fine-tuned the camera angle so that the sun appeared to be setting above the lowest part of the horizon, with the tip of a willow branch hanging down from above. Getting the right exposure for a silhouette is easy; you simply meter off the sky to one side of the sun.

Camera Protection

Being properly attired with adequate protection for a conventional camera may often prove to be an infinitely more important factor in achieving a shot than having a camera with a high price tag.

Photographing while it is raining or snowing can produce some exciting and novel images. Care must be taken, however, to prevent raindrops or snowflakes from landing on the front lens element or filter. With today's state-of-the-art electronic cameras,

Snow falling on black wolf *(Canis lupus)*, Utah, February. *Nikon F4, 200–400mm f/4 lens, Ektachrome 100 Plus (C).*

To photograph the wolf in a snowstorm, I covered both the camera and the lens with a waterproof Cameramac. Additional protection was provided by an umbrella clamped onto the tripod above the camera. The large snowflakes would have made it difficult to separate a typically colored timber wolf from the snow and brown stems, whereas this black individual was clearly visible through the heavy snow.

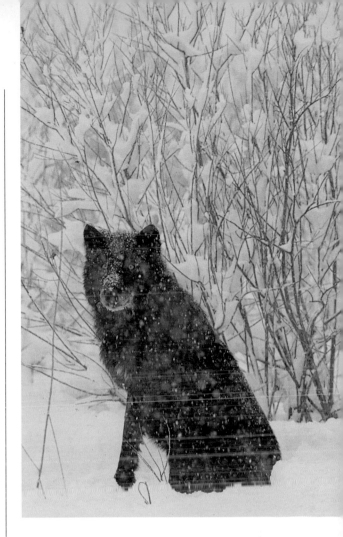

you also have to make sure that neither raindrops nor snowflakes come into contact with any part of the circuitry, including the flash contacts. With zoom lenses, moisture can get inside and cause internal lens elements to steam up, making them unusable until they can be dried with a car heater or a hair dryer. To reduce this risk, use a small hand towel to dry off any moisture that gets on the camera.

Getting some of the pictures for this book involved taking more risks with my equipment than usual. Yet, like many things in life, working to the limit can bring some rich rewards. My motto is that if a great picture can be had, the risk is worth taking. On the other hand, if the light is abysmal or the subject uncooperative, it would be more prudent to pack up until later.

The following are some useful accessories for protecting equipment from water or snow:
- Plastic bags with rubber bands; even a shower cap will protect a camera body in light rain
- Customized rainproof covers, made by Cameramac or Laird
- Transparent or neutral-toned umbrella fitted with a clamp
- Absorbent hand towel
- Heavyweight trash can liners
- REI small vinyl clear sacks for individual lenses
- Waterproof ground sheet or large trash bag
- Pelican watertight equipment case

Several times, while I was working alongside other photographers, a rain or snow shower resulted in a flurry of activity, as cameras and lenses were hastily stashed away into gadget bags or photopacks. As I produced a waterproof, made-to-measure camera cover and extracted an umbrella fitted with a clamp, I would hear somewhat begrudging murmurs of approval. Throwaway shower caps, supplied by many hotels, are always worth pocketing for protecting a camera body during a light shower. A plastic bag secured with a rubber

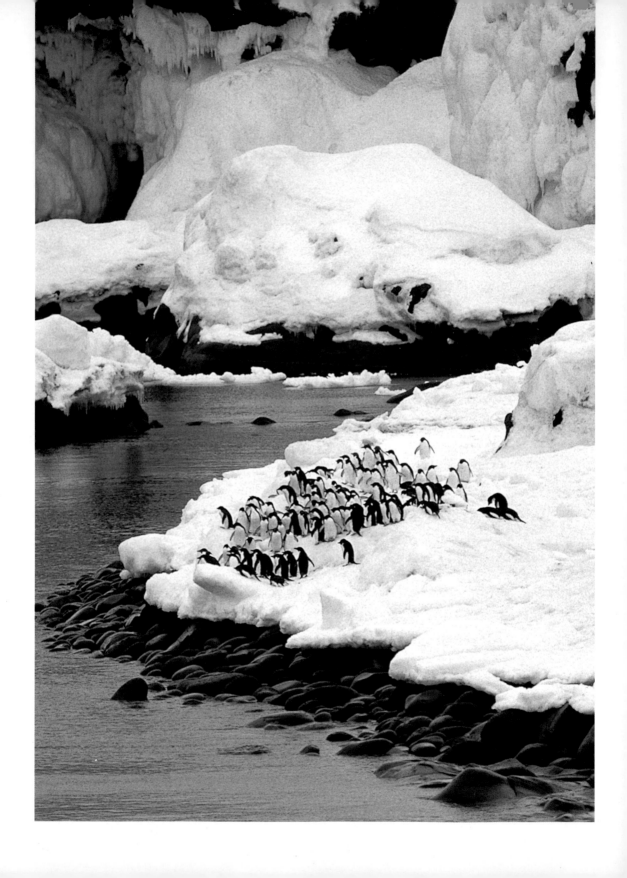

band around the lens barrel will protect both body and lens.

Prolonged shooting sessions in rain or snow, however, require greater protection. I use a series of customized rainproof covers made in England by Cameramac. Provided the correct cover is used with each camera and lens combination, it is a most effective barrier to water and snow. The main snag is when you need to change film. This is why I also carry a neutral-toned umbrella with a metal center column. I remove the handle and flatten the last couple inches of the column so that a hole can be drilled through large enough to attach a small clamp (I found one in a baby-care store for clamping an umbrella onto a stroller), which is fixed to the tripod. Then, as long as I am not working in driving horizontal rain, the camera has complete protection from the elements when I need to change film or replace batteries.

Even with such protection, equipment that has been used in humid conditions should, at the first opportunity, be removed from the camera bag, the caps removed from all lenses, and every item laid out to dry thoroughly before the next shoot.

Wading into water or working from a small boat without a weatherproof or underwater camera also increases the risk of damage to equipment. Quite simply, cameras and water

do not mix. Over the years, I have lost several cameras that were accidentally submerged. Just a few inches of seawater was enough to write off a Hasselblad in the Seychelles. I managed to salvage another mechanical Hasselblad after a dip in a river by taking it apart and drying it out with the car heater on high. Another time, when a Nikon F4 ended up in the shallows of a freshwater lake, a mere twenty-minute drive from the UK Nikon headquarters, I was hopeful it could be saved. But by the time I handed it over to the technicians, still festooned with water plants, it was already history. Fortunately, they managed to save a favorite 300mm ED lens attached to the camera by stripping it down and thoroughly drying it with a hair dryer.

When working for any extended period in a boat, whether it be whale-watching in the sea, island-hopping in a smaller boat, or rafting down a river, a conventional camera bag is better replaced with an unbreakable waterproof Pelican case. Available in various sizes, the case comes with a hefty O-ring seal that makes it completely watertight to 30 feet—when closed! More than once I have seen gear drenched because a case was left open in the excitement of the moment. Made from an ultrahigh-impact structural foam resin, the case also has the advantage that it floats when fully loaded.

A tough trash can liner capacious enough to accommodate a large photopack, provides complete protection from salt spray when transporting a pack in an inflatable Zodiac boat, particularly in choppy seas. On landing I either stuff the liner in my photopack or look for large stones to anchor it to the shore well above the high-water mark, where it can be retrieved for the return journey. Small REI clear sacks that are sealed with a roll top are useful for transporting individual long lenses in situations where there is any risk of water, salt spray, or snow wetting gear. I use one to

Adélie penguins *(Pygoscelis adeliae)* on Bellingshausen Island, Southern Ocean, November. *Nikon F4, 500mm f/4 lens, Kodachrome 200.*

I was attracted to what was essentially a monochromatic picture by the band of gray pebbles projecting beyond the snow cover and the ever-changing pattern of the adélies as they turned their black backs or white fronts toward the camera. It was worth the effort of setting up in the pouring rain, with a Cameramac protecting the camera and long lens.

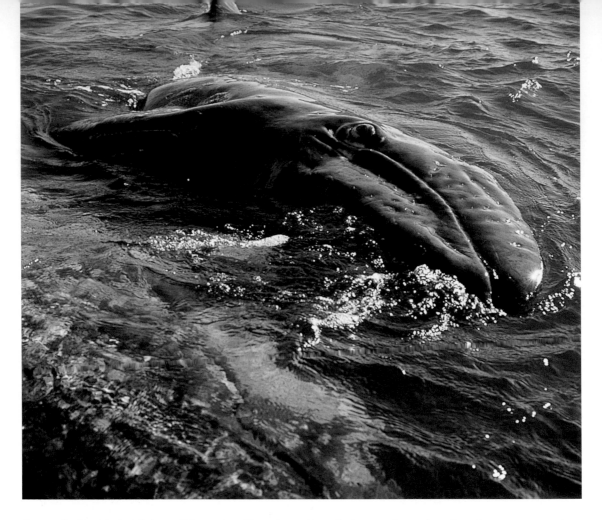

Gray whale *(Eschrichtius gibbosus)* calf surfaces beside its mother, showing the eye set at the back of the jaw, Magdalena Bay, Baja California, Mexico, March. *Nikon F4, 20mm f/2.8 lens, Kodachrome 200.*

You have to be adaptable when working whales from boats. Most of the time, a 300mm lens is a good length and is easy to hand-hold, but I always have a spare camera fitted with a wide-angle lens. So when a mother gray whale and her calf swam up to our inflatable Zodiac, all I had to do was grab the camera to get my shot. The mother came so close we could touch her flank.

carry my 500mm f/4 lens in hand when traveling short distances through shallow water or over gentle, snow-covered inclines.

A tough plastic trash can liner is invaluable for laying on wet or snow-covered ground to keep a photopack and other items dry. Alternatively, a triangular-shaped pocket known as an apron support, made by Bogen (Manfrotto), can be strung between tripod legs to make an invaluable temporary gadget shelf.

Biting flies can be pests during summer in some wetland sites. A head net will help keep them off your face, but it will not prevent an insect from getting inside the camera as you change a lens or film outside. The best solution is to return to a vehicle or find a hut.

Films, Lighting, and Exposure

Choosing the Right Film

From the plethora of color films now available, it can be daunting to try to select the most appropriate one. There are several factors to consider.

Your first decision is whether to use print or transparency (slide) film. What is best for you depends on how you plan to use your pictures. If your goal is reproduction in magazines or a book, slides are the best medium. If you wish to sell prints, you could opt for black and white or color print film, although prints can be made from slides. Slide films have much less latitude than print films, so therefore the exposure is much more critical.

Your next decision is the film speed. Both color print and slide films range from ISO 25 to 1600. The ISO number indicates how sensitive the film is to light. A film with a low number is less sensitive to light than a film with a high number. When the light is good,

slow-speed films can be used for any subject. It is also possible to use them for landscapes, trees, and flowers when the light is poor and there is no wind.

In addition to the level of the ambient lighting, other factors to consider include the distance of the subject from the camera, whether it is moving, and the size of the maximum aperture of the lens. A fast $f/2.8$ lens will allow a faster shutter speed to be used with the same film speed than a slow $f/5.6$ lens. A brown bear standing motionless at the top of a waterfall waiting for a salmon to leap could be taken with a slow $f/5.6$

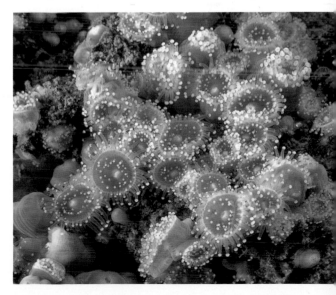

Jewel sea anemones (*Corynactis viridis*), Guernsey, Channel Islands, UK, March. *Nikkormat FTN, 55mm f/2.8 Micro-Nikkor lens, Kodachrome 25.*

For this detailed close-up of expanded sea anemones in an aquarium, I wanted as much detail as possible, so I opted for the slowest slide film, which is essentially grain-free.

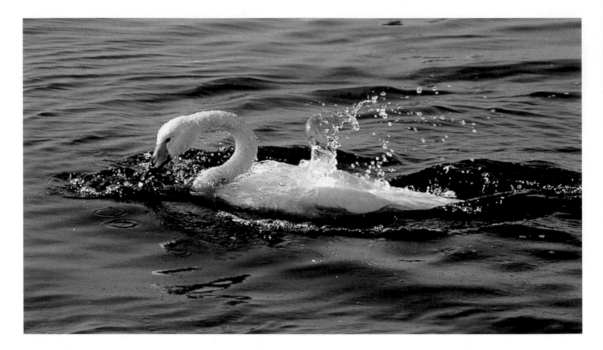

Whooper swan *(Cygnus cygnus)* bathing, Hokkaido, Japan, January. *Nikon F4, 300mm f/4 lens, Kodachrome 200.*

Because I wanted to freeze the movement of the seawater rising up from the swan's body, I needed to use a shutter speed of at least 1/250 second. This in turn dictated a medium-speed film of ISO 200.

300mm lens and a shutter speed of 1/30 of a second in poor light; if you want to catch a sharply defined salmon in midleap, however, you will need to use a shutter speed of at least 1/250 of a second, preferably 1/500, with a fast, long lens. This will be possible with a slow-speed film only when there is plenty of light; otherwise, a much faster film will have to be used. Using a fast, f/4 or f/2.8, long lens will help you gain an extra stop or two, thereby achieving a faster shutter speed. Thus, if your objective is to achieve crisp images of action, the choice of film speed will be determined by the light level and the maximum aperture of the lens.

Another consideration is how a film reproduces particular colors. Since we all see colors differently, the way we interpret how

they appear on different filmstocks will inevitably also vary. Every outdoor photographer has his or her own preference for a particular film. Even so, this may not prove

Sunrise over the Sea of Cortez, Baja California, Mexico, March. *Nikon F3, 80–200mm f/2.8 lens, Kodachrome 200.*

Disappointment over an abortive Zodiac ride at dawn for leaping dolphins was more than compensated by the reflection of the sun rising as a fireball. By hand-holding a zoom lens, I was able to quickly vary the position of the horizon within both vertical and horizontal frames. I like the way the uniform reflection of the rich sky is broken by horizontal shadows cast by gentle undulating waves.

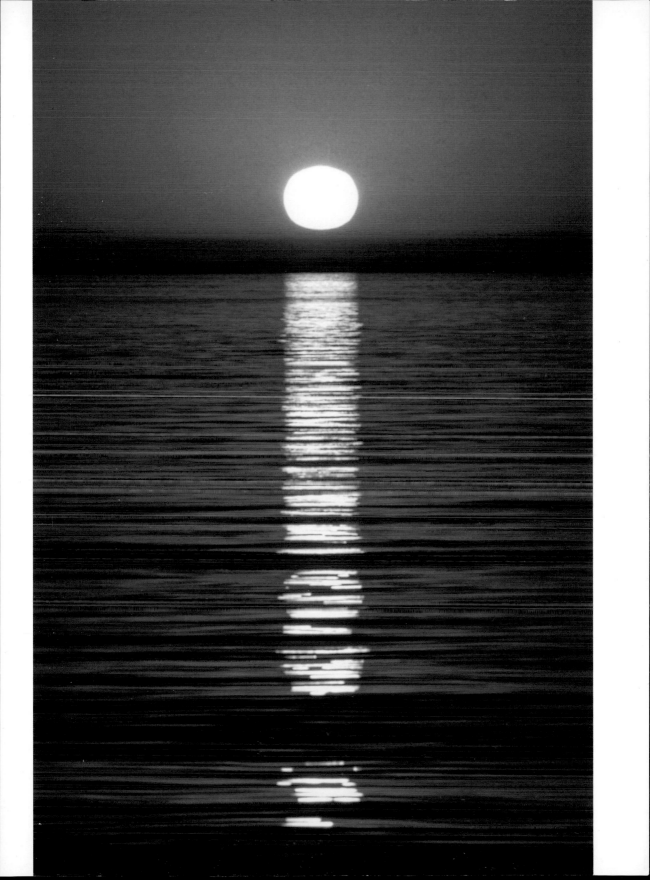

Goldfish swimming in a garden pool, Forbidden City, Beijing, China, October. *Nikon F3, 105mm f/3.5 Micro-Nikkor lens, Kodachrome 25.*

For this photograph, taken in poor light with the slowest color slide film available, I was able to use a 1-second exposure to create deliberate blur. This picture works because the silky-edged bodies of the fish contrast well against the water. With the fish constantly on the move, there was no way I could compose the picture.

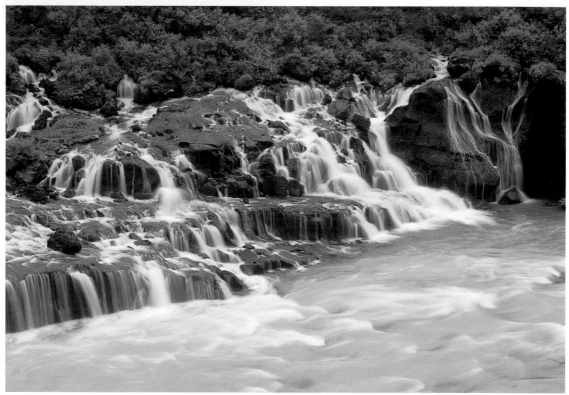

Hraunfossar on Hvita River, Iceland, July. *Hasselblad 501 CM, 120mm f/4 Makro-Planar lens, Ektachrome 100S.*

Without any trees or canyon walls to cast shadows, this open, bifurcating waterfall, which emerges from beneath the edge of a shrub-covered lava field, is always well lit. So the only way I could get a slow enough shutter speed to blur the moving water was by using a 4X neutral-density filter, which cut out two stops of light.

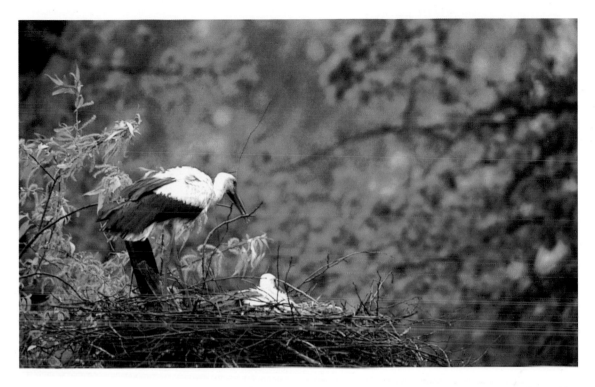

White or European stork *(Ciconia ciconia)* returning to nest with twig, Poland, May. *Nikon F4, 500mm f/4 lens, Ektachrome 200 rated at ISO 400.*

By using a van as a mobile blind and a window mount to support the camera, I was able to keep dry and continue working in persistent rain. As the light began to fail, I had to double rate the fastest film I was carrying so I could continue shooting at 1/250 second.

ideal for every situation. Velvia is well known for highly saturated colors, which result in vibrant fall foliage pictures. By no means, however, are all colors in the natural world highly saturated, and greens in particular come in a subtle range of tones and shades. For each transparency film, you need to learn the nuances of how it reacts in different lighting conditions. By viewing and appraising every frame on a light box with a loupe, you will learn to predict how the film will perform. When I make an appraisal, I consider the following:

- Are the colors true to nature?
- Is any significant grain apparent?
- Is there any detail in the shadow areas?

- How does the film perform in low light levels?
- Is there a shift in the color balance when the film is pushed beyond the nominal speed?

In low light levels, you may have to use a film other than your preferred one. It is no good being wedded to one particular brand if, even when using fast, long lenses, the obligatory slow shutter speed in poor light results in a picture with unintentional blur.

For static subjects such as wet rocks, calm water, snow-covered landscapes, frozen waterfalls, icicles, and fallen wet leaves, a slow-speed film such as Velvia (ISO 50 but often rated at ISO 40) or Ektachrome 100S or

100SW can be used, regardless of the light level. Slow-speed films are also infinitely preferable for achieving deliberate blur with moving water (see page 8, 42) by using a slow shutter speed, although the effective speed of faster films can be reduced by using a neutral-density filter, which, depending on the strength, can hold back one to three stops of light.

Life is much easier in many ways if you confine your photography to one broad-based genre, such as landscapes or close-ups. Then you will not have to lug around such a wide range of lenses as photographers like me, who never want to pass up any wildlife opportunities. Also, you will not need to carry fast films to photograph active subjects in poor light.

If you regularly work with two camera bodies, each can be loaded with a different speed of film so that you can change the speeds to suit the subject without having to wind back partly exposed films and reload at a later stage.

Pushing Films

When taking active animals at first or last light with long lenses, I invariably need more speed than ISO 50 or 100 so that I can use a reasonably fast shutter speed. In the past, I opted for Kodachrome 200, but now I prefer to use Ektachrome 200. Not only do the colors appear true to life, but also the grain on unpushed films is virtually undetectable using an 8X loupe on a light box. Even when E200 is pushed one stop (uprated to ISO 400), the colors remain natural without any color shift, there is no obvious grain, and the contrast is not reduced in the shadow areas. Not so many years ago, ISO 200 films showed such conspicuous grain that I used them only as a last resort in fading light. How is it that the quality of E200 is so superior? In a nutshell, the T-Grain technology incorporated within the emulsion provides extremely fine grain and a high degree of sharpness, giving it the finest grain structure of any daylight ISO 200 transparency film available today. It also shows excellent reciprocity at speeds from 10 seconds to 1/10,000 of a second without any need for additional exposure or corrective filters.

Another huge advantage E200 has over K200 is that since it is processed using E6 chemistry, it can be sent to any laboratory that processes slide film. What is more, if you deliver the film by hand, you can view the results within a couple of hours.

Generally, the faster the film, the more pronounced the grain will appear, but in recent years, the major film manufacturers have been striving to produce grain-free film, so that on Fujichrome Multispeed MS100, which can be rated at various speeds from ISO 100 to 1000 (100, 200, 400, 800, or 1000), the grain is virtually undetectable. Even on the two fastest slide films currently available, Ektachrome P1600X and Fujichrome Provia 1600, which are designed specifically for push processing and can be rated at ISO 800 (push 1 stop), ISO 1600 (push 2), or even ISO 3200 (push 3), the grain is not too obvious other than in large unitoned areas. All three films are useful for freezing the rapid action of an erupting geyser (see page 94) or for taking animals moving at first and last light. Once you have decided to push any film, this speed must be used throughout the entire roll, which should be clearly marked. I use self-adhesive labels, on which I write the amount the film has been pushed. Any pushed films must be segregated for processing, since they need extended development. There is usually a surcharge for this special service.

As film manufacturers produce enhanced-quality films without any detectable grain, it is becoming increasingly difficult to use grain in a creative way. One technique that helps increase granularity is to underexpose the film and then to have it overdevel-

oped. Grain helps to introduce a sense of mood to any picture, arguably most of all a landscape.

Exposure

At any given moment there is one and only one correct exposure value (EV) for a particular film speed. Correctly exposed pictures can be taken by sticking with a single shutter speed. I have met people who abhor using a tripod and shoot everything at 1/250 of a second. This is sad, for it is not only quite unnecessary for static subjects but also completely uncreative. Exciting images are achieved by using the combination of shutter speed and aperture that will portray the subject to the best advantage with whatever lighting conditions are available. Some hawk-eyed readers may, at this stage, be pondering why, if exposure is so important, it is not included in each caption. The reason is partly lack of time, for if I slavishly wrote down every exposure, I would miss some decisive moments; but more to the point, no one else is likely to experience identical lighting on the same subject, using the same filmstock and lens. What may be useful, however, is to learn the reasons why I selected a very fast or a very

Sun breaking through rain clouds over Auckland Islands, Southern Ocean, December. *Nikon F4, 80–200mm f/2.8 lens, Ektachrome 100 Plus.*

When at sea, I prefer to spend my time up on deck, which means that I often experience magical, transient lighting. It was late in the day, and my cameras were in my photopack, but as I saw a chink of light appear, I grabbed a camera and metered off the sky at the top of the frame, waiting for the bright area to increase. I took just three shots before the clouds closed in for the day.

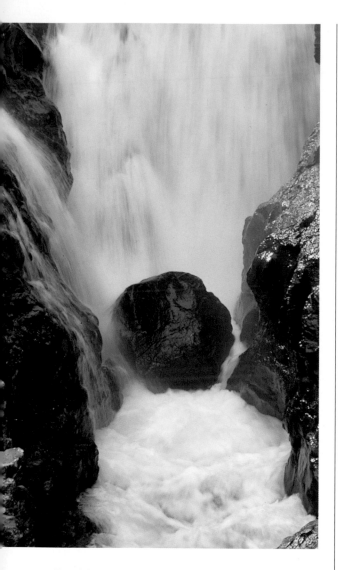

Boulder wedged between canyon walls at base of waterfall on Oxara River, Iceland, July. *Nikon F4, 300mm f/4 lens, Ektachrome 100S.*

I metered this shot two different ways. Checking that most of the frame was not lit by direct sunlight, I manually metered off green grass (a good average tone) adjacent to the falls that was lit in the same way. Then I manually spot-metered off the turbulent white water and opened up two stops. Both gave me an identical exposure of 1/8 second at f/22.

slow shutter speed, or why I opted for a large or a small aperture. These parameters are included in some captions.

SLR cameras offer a choice of metering methods. The *center-weighted* mode reads the light over the entire area of the frame, with special emphasis on the center portion. *Matrix* (Nikon) or *evaluative* (Canon) mode meters the light as a series of segments within the frame and aims to match them with images held within the camera's database (the Nikon F5 stores data from more than 30,000 scenes). If precise metering of a small area within the frame is required, a spot sensor is used. Not all cameras have this facility, however.

From talking to my workshop participants, I know that understanding how to cope with tricky exposures is an all-too-frequent headache. The heart of the matter lies with through-the-lens (TTL) metering measuring the light reflected from the subject. For an average-toned scene, this is fine, but problems arise with brighter- or darker-than-average scenes. In-camera metering constantly strives to reproduce a midtone, which is why snow or white water scenes appear gray (underexposed) and black rocks or large shadow areas also appear gray (overexposed) when the camera's TTL reflected reading is not corrected.

My preference is to work in manual mode and adjust either the aperture or shutter speed accordingly. The crunch question is, how do you decide the extent of the adjustment?

One solution is to use a separate hand-held meter to measure the incident light falling on the subject and then manually set the exposure on the camera. Without a separate meter, it is still possible to use the camera's TTL meter. Even if you shoot color stock all the time, you need to learn to look at compositions in terms of tones rather than colors. Although my Nikon F4 and F4S cameras have several automatic exposure

modes, I prefer to manually meter nearly all my shots. Exceptions are when taking moving subjects in rapidly changing light or when photographing illuminated scenes at night. Even when I am not actually taking a picture, I am constantly metering portions of a scene so that I am aware of the variation, and should a picture suddenly present itself, I know what exposure to use.

If there is an area of green grass or gray rocks lit in the same way as the subject, I manually meter off them and stick with this exposure. Without a convenient grassy area or gray rocks, or an incident hand-held light meter, it is possible to judge the degree of exposure compensation with practice. For instance, a frame-filling white scene will need to be opened up one and two-thirds stops. On the other hand, if an area of white water cascades over black rocks so that each occupies roughly 50 percent of the frame, then you can go with the camera's matrix metering, since the dark rocks will be compensated for by the white water.

Automatic Metering

Using one of the camera's automatic exposure modes can be useful in situations where

Mass of whooper swans *(Cygnus cygnus)* in the sea, Hokkaido, Japan, January. *Nikon F4, 80–200mm f/2.8 lens, Ektachrome 100 Plus.*

As the wild swans jostled for food, their bodies became so tightly packed they virtually filled the frame. Like snow, their white feathers are highly reflective, so the in-camera reading must be corrected or the swans will appear gray. In this case, I opened up one and a half stops on the matrix reading.

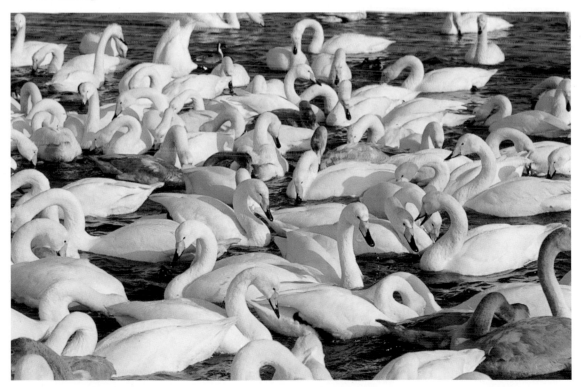

Bull kelp *(Durvillea antarctica)* fronds snaking in the sea, near Dunedin, New Zealand, December. *Nikon F4, 300mm f/4 lens, Ektachrome 100 Plus.*
Like birds with black feathers or mammals with black fur, the dark seaweeds reflect very little light and would turn out overexposed unless the reflected reading is overridden. To determine the correct exposure, I manually metered off a green grassy sward above the intertidal zone.

the light is constantly changing. With *aperture priority,* you set the aperture and the camera determines the appropriate shutter speed (useful if you need to gauge the amount of depth of field), whereas with *shutter priority,* you select the exposure time and the camera determines the aperture (useful if you want a fast or a slow shutter speed). With a *program mode,* the camera allows the photographer no choice, since both aperture and shutter speed are preselected.

Autoexposure modes are fine so long as the scene is an average tone. If it is not, some exposure compensation will be necessary.

For bright subjects, this will mean opening up (+), and for dark subjects, closing down (–) the reflective in-camera reading.

Silhouettes

The art of taking a successful silhouette lies not in skillful metering, but in selecting a viewpoint and lens that ensure the composition is an uncluttered one, as the best shots are always the simplest. Equally effective in monochrome or color, this simple technique dates back to the eighteenth century, when a Frenchman, Étienne de Silhouette, cut out profile portraits from black paper.

Silhouettes are most often sought against the sky, but waterside or emergent plants, and even wildlife, can be effectively isolated against bright water. The most striking silhouettes will be achieved by using natural color reflected from a dawn or dusk sky, although colorless water can be enhanced by using an orange sunset filter. For an animal to be recognizable as a silhouette, it needs to be taken side-on so that any distinguishing feature, such as the shape of the bill or leg length of a bird or the fin or fluke of a whale or dolphin, is immediately discernible. With an uncluttered bright background and a side view of a uniquely shaped animal, such as a flamingo, the subject can be quite small within the frame.

Metering for silhouettes is easy with either manual or auto mode. Simply meter off the bright sky (not the sun) or bright water behind the subject, and go with that exposure. This will cause the backlit subject to be underexposed to such an extent that no detail of color, texture, or tone appears, and the eye can concentrate on the solid shape. A few reeds or grasses

Orca or killer whale *(Orcinus orca)* silhouetted, Robson Bight, British Columbia, Canada, July. *Nikon F4, 300mm f/4 lens, Kodachrome 200.*

The orca's daggerlike dorsal fin is so distinctive it can be recognized instantly from a silhouette. With movement from both the boat and the whale, a shutter speed of at least 1/250 second was essential to avoid a blurred fin. In the fading light at the end of the day, I had no option but to silhouette the whale, metering off the bright water and sky.

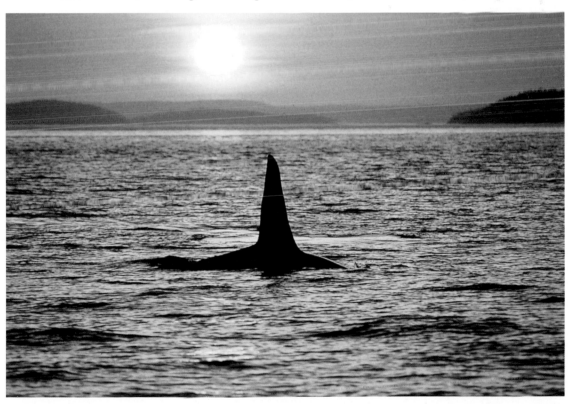

HOW TO PHOTOGRAPH WATER

emerging from the water at an angle so that the mirror image appears bent in the opposite direction are among the simplest of silhouettes readily available. Trees that have been killed by flooding make shapely silhouettes on their own, and perching birds provide additional interest.

A dramatic silhouette can be created by using a warm backdrop of the preglow or afterglow sky before the sun rises or after it has set. At these times of day, when the sky color is reflected in water or ice, it enlivens pictures of whales or dolphins surfacing or polar bears walking on ice. The light level is then so low, however, that a faster film may be needed to freeze moving whales, swans, or geese in flight, since a blurred silhouette will never impress. Silhouettes also fail when it is not apparent where one plant or animal ends and another begins.

When shooting silhouettes against water, look for an elevated viewpoint, such as the top of a vehicle, a riverbank, a bridge, or the upper deck of a boat, to get a uniform background of water across the entire frame.

When taking silhouettes or any backlit shot, check that the sun is not shining directly into the lens. Problems may arise when using a zoom lens, so use either a hand as an extended lens hood or fit a Flare Buster, a circular solid foam shade attached to a flexible arm that is fixed to the camera's hot shoe or a tripod.

Modifying Light

Light on landscapes can be modified by means of filters (see page 13), whereas close-range shots can be modified by using reflectors, diffusers, or flash. Since reflectors and diffusers are most useful for taking close-ups, they are covered in that section.

Using Flash

Since both water and ice are highly reflective, direct flash has to be used with discretion when photographing either of these subjects. It will, for instance, illuminate falling rain or snow so that it appears as white streaks across the frame. Nonetheless, flash is an extremely useful tool for reducing the tonal discrepancy between poorly lit foreground subjects and a bright background, especially when shooting into the light. Depending on the degree of underexposure of the flash compared with the ambient light exposure, it can be used simply to fill in shadows or to spotlight the foreground.

Flash is also invaluable for creating a highlight in the eye of a dark-eyed bird or mammal, for nothing appears more lifeless than a dark eye without a highlight, whether caused by natural sunlight or a flash. Using a Nikon F4, I go with the daylight exposure and underexpose a Nikon SB26 flash by one and two-thirds stops so that it does not affect the overall exposure.

If flash is used to illuminate subjects on or underwater, such as fish in a pond or life in a rock pool, it must be moved off the camera's hot shoe using a flash extension lead so that it can be directed in at about 45 degrees to the water, thereby ensuring that a reflection from the surface does not appear in the field of view (see page 126).

When backlit, icicles come to life with an inner glow and glints appear around their margins. Even on an overcast day, this effect can be achieved by backlighting with a flash. All you need is a good length of extension and a spiked pole topped with a flash shoe connection or an assistant to hold it in position. In either case, look back along the line from the flash toward the camera to check that it will not shine directly into the lens, thereby causing flare.

The Magic Hour

Anyone who wants to produce dramatic and memorable landscapes should plan a shoot during the "magic hour." For a brief period twice each day, if conditions are right, a scene is transformed as it becomes

34

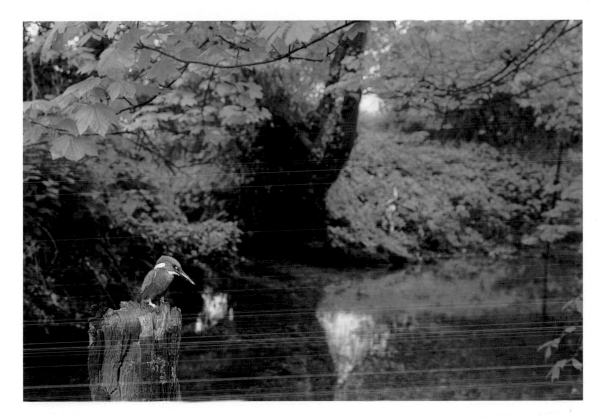

Kingfisher *(Alcedo atthis)* on fishing post in feeder of River Test, Hampshire, UK, June. *Hasselblad 500 C/M, 80mm f/2.8 Planar lens, Ektachrome 64.*

I had to get the appropriate permit to photograph this comparatively rare bird near its nest, using a blind beside the river. Once inside the blind, I checked the exposure with a Polaroid back. I wanted to use the natural backlight streaming through the trees, but I needed fill flash to add color to the kingfisher, so I fixed a flash on a tripod on each side of the blind. I used several lenses, but this one shows the riverine habitat most clearly and depicts the kingfisher as a living jewel against the river.

painted with the fiery hues of the first (or last) rays of daylight and the cold blue shades of night.

Because this is a combination of two distinct kinds of light, the subtle effect of the magic hour can never be created by means of a filter. The investment in time therefore has to be considerable if the rewards are to be worthwhile.

Even though the colors will interact for an hour, they constantly change. You need to load up with fresh film, preferably having two bodies at the ready, to avoid wasting precious time reloading, since the perfect shot may last for only a matter of seconds.

Although the warm hues known as alpenglow are seen on the summits of mountains just before and just after the sun is above the horizon, it is not the sunrise nor sunset itself, rather the effect of the warm rays selectively painting portions of the sky, clouds, water, or land. It is possible to get dawn or dusk pic-

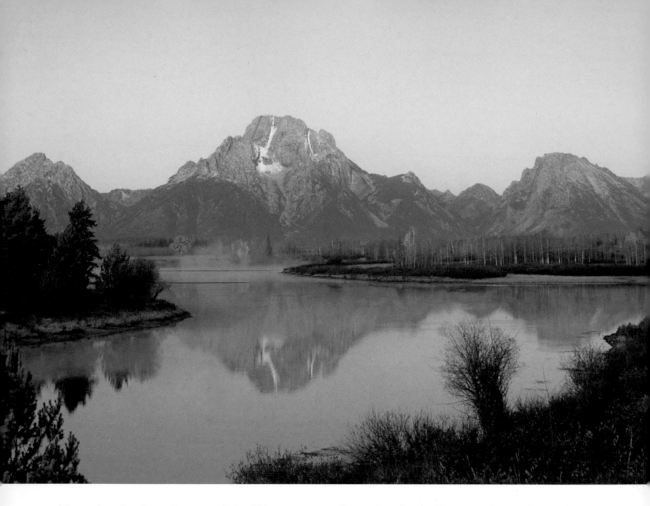

Alpenglow bathes the top of the Teton range reflected in Snake River at dawn, Grand Teton National Park, Wyoming, October. *Nikon F4, 80–200mm lens, Fuji Velvia.*

Every day brings a different light to this very popular viewpoint for photographers. I arrived while it was still dark so I could set up my tripod and be ready for the precious few moments when the alpenglow began to bathe the top of Mount Moran. The mist cleared in time for the colored peaks to enliven the still water with their reflections. Compare this with the photo taken in midsummer on page 59.

tures with the moon in the sky and alpenglow bathing foreground objects as well as distant peaks and clouds in the sky.

Avid landscape photographers know the precise viewpoints and times of day to set up their tripods to optimize the effects of alpenglow on snow-covered peaks so that the white face becomes painted with the reflection from a pink or orange sky that develops behind the camera. Any hint of cloud will impinge on the uniformity of a colored wash, and as I found at Darjeeling, India, atmospheric pollution will mask and dilute the vibrant colors.

Calculating the correct exposure can be tricky when there are large areas of shadow in the frame. I usually spot-meter the warm light on bare (not snow-covered) rocks.

Aqua:
A Heather Angel
Portfolio

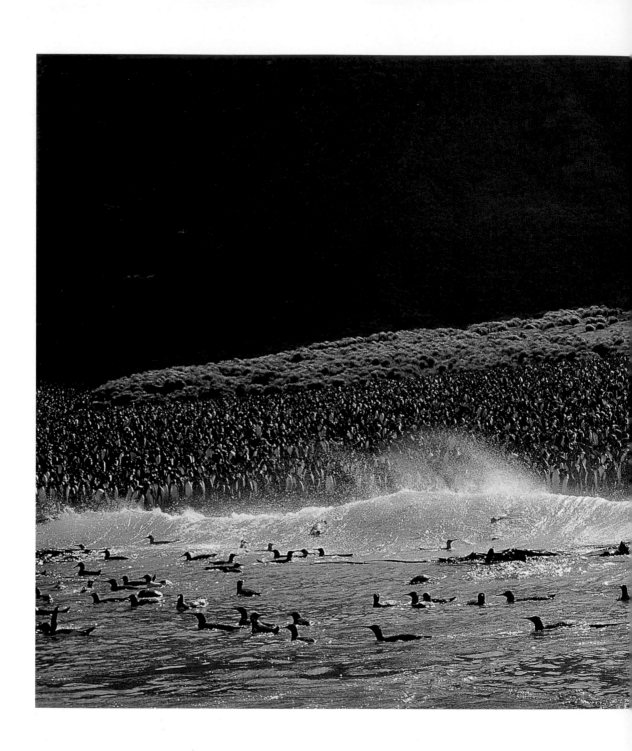

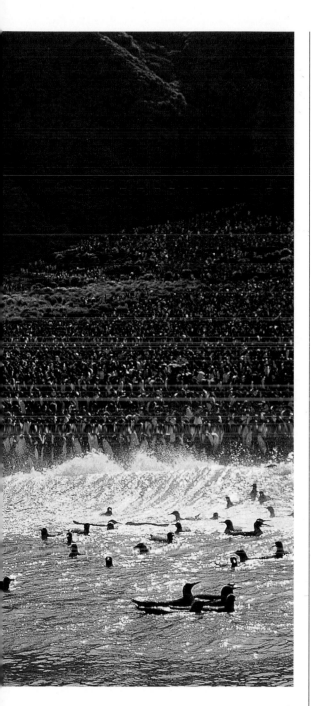

Water has always held a great fascination for me. Indeed, it was while working as a marine biologist that I began to take pictures of marine life. Compiling this section has been something of an indulgence, taking me backward on a journey through time, whereby I could assemble my favorite pictures depicting water. One was taken in my own garden; another was at the opposite end of the earth, in Antarctica.

Unlike the other pictures in this book, which were chosen to illustrate a particular technique or editorial point, each image here not only gave me great pleasure in taking it but also conjures up a quintessential aspect of water.

The techniques I used to achieve them were often quite basic. At those moments, I was simply out there and moved to take what I saw. There was no time to rethink the shot; I had to go with my initial instincts. But even the waterfall taken almost a couple of decades ago has stood the test of time.

Before we reached Macquarie Island in the Southern Ocean, we had been briefed that the king penguins would swim out to meet us; sure enough, as we took to our Zodiac, the penguins encircled our inflatable. It came as no surprise to learn that landings are prohibited on this beach, which seemed to have no room for even another penguin to squeeze in among the thousands of birds already in residence. After hours of rain at sea, the skies began to brighten as we took to the water.

The clouds parted momentarily to backlight the breaking surf and silhouette the penguins bobbing corklike in the surf. By lying across the side of the Zodiac, I was able to shoot just above the water line. This is what being a wildlife photographer is all about—experiencing those unbeatable moments when everything gels.

King penguins (Aptenodytes patagonica) in surf, Lusitania Bay, Macquarie Island, Southern Ocean, December. *Nikon F4, 80–200mm f/2.8 lens, Ektachrome 100 Plus.*

Pregnant harp seals haul out on floating pack ice to give birth, and the easiest way to reach them is to land on the ice by helicopter. The ice is far from uniform; uplifted ice sheets and leads—open water channels between the ice—have to be negotiated with care. The temperature is always cold on ice at sea, but when a wind blows, it can plummet down to –4 degrees F (–20 degrees C) or below. On this particular day, when I landed after an overnight blizzard, everything was covered with snow, and I failed to see a single pup where there had been plenty the previous day. As the temperature slowly rose, I began to see the odd black eye in the white blanket. Several hours later, this pup, still encrusted with snow,

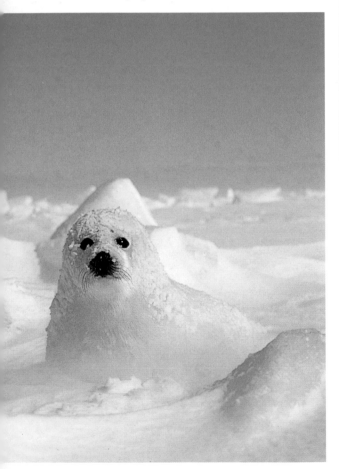

raised its head to focus a pair of soulful black eyes on mine, and I had my best shot. Working in these conditions, it is essential your body be well insulated, or you will not be able to concentrate completely on your photography. Electronic cameras fail all too readily in cold conditions unless the battery compartment is insulated with a chemical hand warmer or the camera is powered by a remote battery pack.

Harp seal *(Phoca groenlandica)* pup on pack ice, Gulf of Saint Lawrence, Canada, March. *Nikon F4, 300mm f/4 lens, Kodachrome 200.*

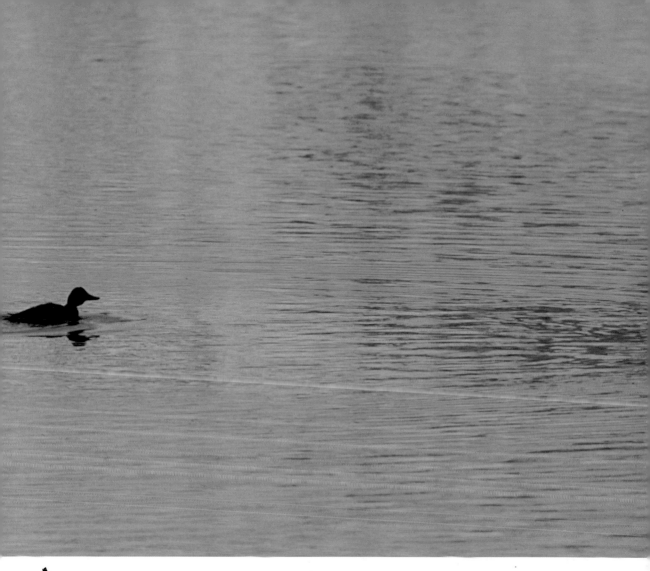

After an early-morning shoot in which I took wide vistas of aspen-covered hills reflected in a lake, the wind began to ripple the surface and spoil the scene. As I began to pack up, I spotted a distant diving duck rise above the surface, creating a striking blue wake in contrast to the yellow water. Even with my longest lens the silhouetted bird appears very small within the frame, but it nonetheless encapsulates the essence of that ephemeral golden moment.

A duck swimming on Crystal Lake creates a blue wake within the reflected fall colors, San Juan Mountains, Colorado, September
Nikon F4S, 500mm f/4 lens, Ektachrome 100S.

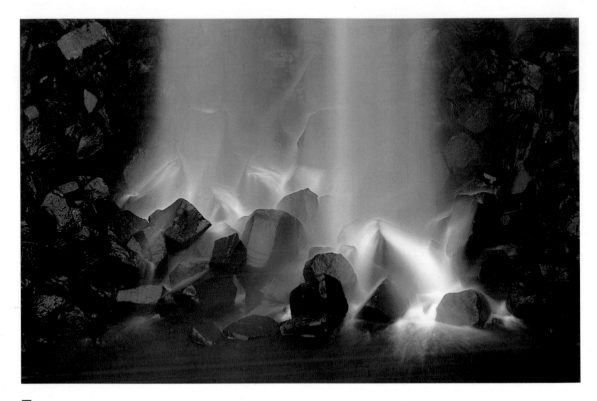

I make no apologies about including a vintage picture of a favorite Icelandic waterfall, quite simply because I have never found another location that comes even close to approaching it. Even though this waterfall is off the beaten track and requires quite a hike to reach, the complete curtain of Svartifoss has been much photographed. Indeed, initially I took a vertical shot of the slender sheet of water with a standard lens. Then I switched to a medium telephoto lens to get a better look at plants growing on rocks to one side of the falls. As I panned the camera, I became riveted by the sheet of white water splashing onto the black basalt rocks below. Instinctively I knew this was the picture.

The decision to make a tight crop with a medium telephoto lens and to use a slow shutter speed of 1 second resulted in a memorable picture that has been widely published, even—much to my dismay—cropped

Base of Svartifoss waterfall, Iceland, July. *Nikkormat FTN, 200mm f/4 Nikkor lens, Kodachrome 25.*

in half as a vertical image for a back jacket. I love the way the slow shutter speed has blurred the water impacting on the black rocks below, in what is essentially a monochromatic picture. If everything gels to produce a striking picture, it is a mistake to return, for one of the magic-making ingredients will invariably be missing. When I did return with my son to Svartifoss seventeen years later, some of the basal rocks had been swept downriver so that the area of white water was increased (see page 8).

After spending several days in Katmai National Park, Alaska, concentrating on photographing my prime target—the bears—I could relax and appreciate other wildlife attracted to the bears' leftovers. By the afternoon, the bears have had their fill, yet they still keep catching salmon. This bear had caught and skinned a fish, which it is holding by a paw on an emergent rock. Opportunist gulls were flying back and forth, ready to swoop in and snatch a free meal the moment the bear released its grip and the current carried the salmon downstream. Because I wanted to convey the interaction between the bear and the gulls in a single picture, the bear has to occupy only a small part of the frame. This picture may not be as punchy as a frame-filling bear carrying a salmon in its mouth, but I love the way the encircling gulls have framed the bear. For anyone who has visited Katmai, it instantly conveys the way that scavengers depend on a predator in this riverine setting.

Brown bear *(Ursus arctos)* with gulls, Brook Falls, Katmai National Park, Alaska, July. *Nikon F4, 300mm f/4 lens, Kodachrome 200.*

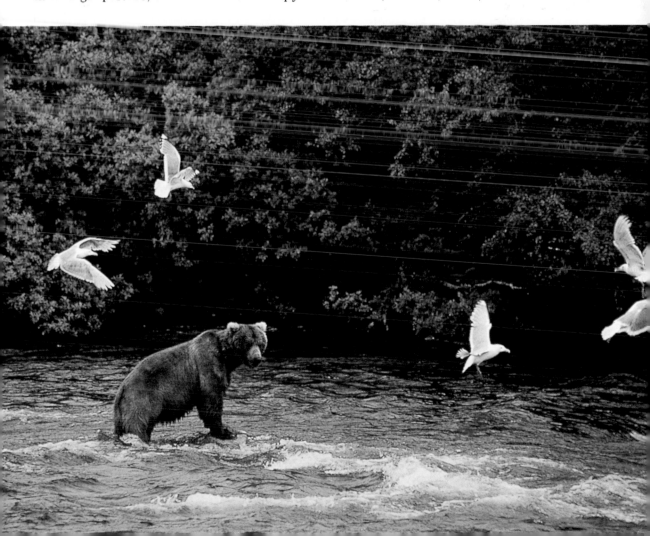

Any plant with large leaves or flower with large petals is worth investigating immediately after a rain shower, for raindrops add a three-dimensional element to flat leaves or petals. Seeing the enrolled petals of this single peony flower hiding the central stamens, I normally would have passed it over, but the raindrops attracted me to take this simple portrait. For anyone who is tempted to simulate rain by spraying water on a leaf or a flower, it never looks the same as the real thing.

Peony *(Paeonia mascula)* flower after rain, Royal Botanic Gardens, Kew, London, UK, May. *Nikon F4, 105mm Micro-Nikkor lens, Ektachrome 100 Plus.*

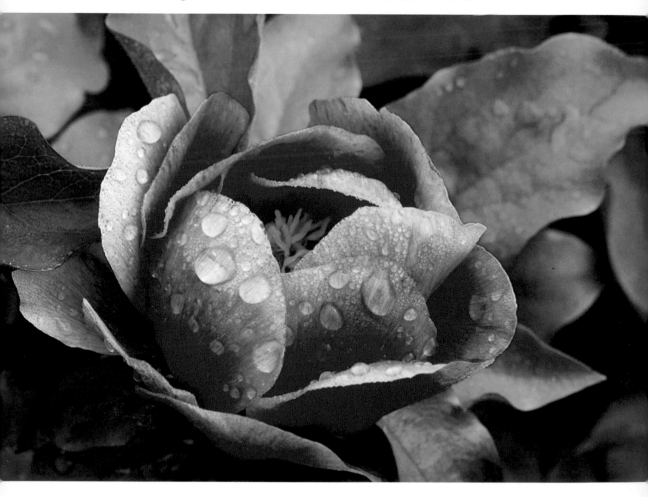

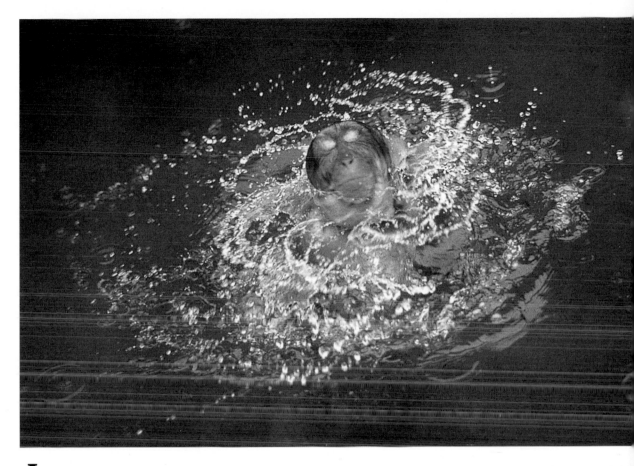

Japanese macaques enjoy bathing in a hot pool, especially in the depths of winter. When they emerge, the wet fur is plastered against the body, and they appear much smaller than when the dry fur is fluffed out. Some individuals wait until they have climbed out of a pool before they shake off the surplus water; others shake their heads as soon as they surface. I was aiming to get the swirling lines of water radiating out from the macaque's head, but I did not notice the closed pallid eyelids until I saw the processed film. As it was raining at the time, I needed to use a medium-speed film.

Japanese macaque (*Macaca fuscata*) shaking off water after surfacing in hot pool, Shiga Heights, Japan, April. *Nikon F4, 200mm f/4 lens, Kodachrome 200.*

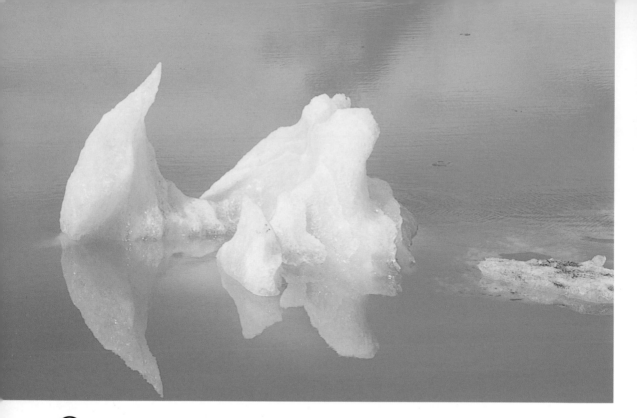

Over a 12-hour period I returned repeatedly to this iceberg to photograph it in changing light. When I arrived at 9 A.M., the weather was overcast, and the gently rippled surface helped separate the pale blue berg from its ill-defined reflection. By noon, the water was calmer, and the berg, now much whiter above, had a ghostly pale blue reflection. Four hours later, at 4 P.M., the almost white berg was reflected in water that was blue from the skylight reflection. At 8 P.M., the colors were reversed, with the light shining behind the berg so that it appeared blue in contrast to the white water. By this time, the lagoon was so calm that the reflection was almost perfect, replicating the left side to resemble an anchor. Notice how the angle of the berg to the shore has changed, as it was moved by currents, and also how I have varied the format. I find it difficult to decide which I prefer, because the two are quite different.

Iceberg with reflection in Jökulsárlón glacial lagoon calved from Breidamerkurjokull Glacier, Iceland, July. *Nikon F4, 80–200mm f/2.8 lens, Ektachrome 100 Plus.*
 Above: At 4 P.M.
 Right: At 8 P.M.

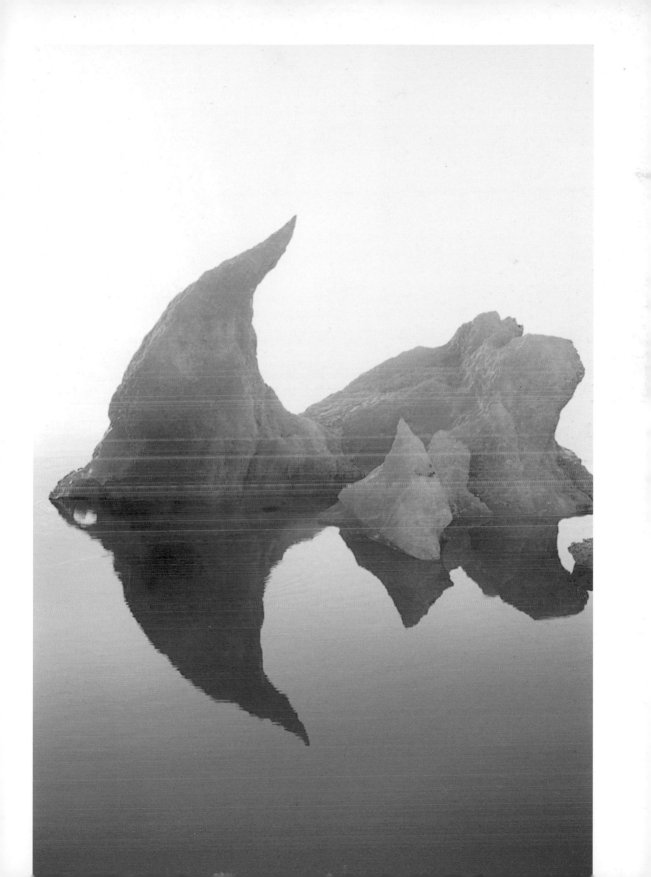

I have always had a great passion for seeking patterns and designs within the natural world, so when I found some potted ornamental cabbages at a local garden center in winter, I visualized the idea behind this picture. All I could do was buy a few plants, put them outside in our garden, and leave nature to do the rest. It took a few nights before we had temperatures low enough to form a frosty coating. Then, early one morning, I chose an overhead viewpoint so the frame was filled with the overlapping leaves. As it was a dull day, I used flash as a fill to add a little sparkle to the frosty-edged leaves.

Frost on ornamental cabbage, Surrey, UK, December. *Nikon F4, 105mm f/2.8 Micro-Nikkor lens, Ektachrome 100 Lumière with Nikon SB-24 as fill flash.*

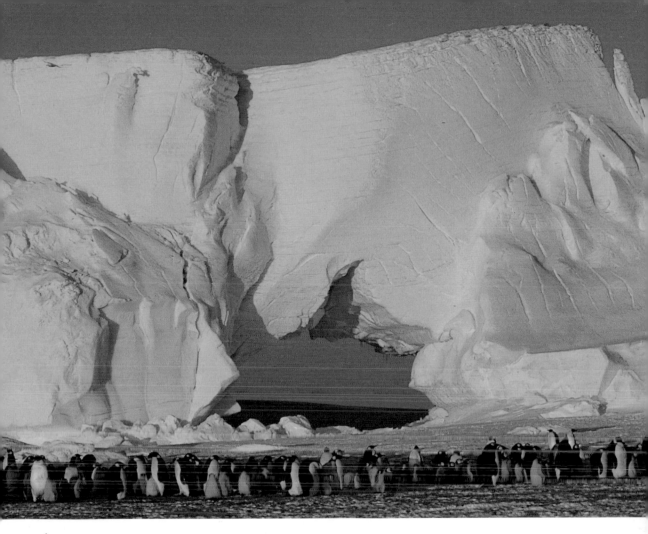

After dragging my gear on a sled for more than a mile across the ice from where we had landed by helicopter, I was rewarded with the sight of my first emperor penguin rookery at midnight (when the sun does not set in the Antarctic summer). I then spent several hours photographing these charismatic penguins around a white ice arch. When the sun became too high for photography, I returned to the icebreaker for several hours. Later in the day, I was back again. As the sun sank toward the horizon, the temperature plummeted, and then, some time before midnight, a white ice arch became suffused with a magical pink glow.

Emperor penguins *(Aptenodytes forsteri)* with chicks against ice arch, Antarctica, November. *Nikon F4, 80–200mm f/2.8 lens, Kodachrome 200.*

All the discomfort of working in very cold temperatures, all the frustration of batteries failing, films breaking, and camera shutters jamming paled into insignificance. This was truly one of the most magical moments I have ever experienced—one that will live with me forever.

Calm Water

In overcast weather, still water on its own is invariably not worth the effort of exposing any film. Under such conditions, it is far better to conserve your film and spend time locating prime viewpoints and camera angles in readiness for a return visit in better light. I have learned to adopt a positive attitude to downtime, which can also occur during windy weather or when the sun is high in the sky. In this way, I am ready for the moments when still water turns to liquid sapphire or is briefly bathed with orange or pink skylight. Then is the time to burn up film.

Ponds and Pools

Images of ponds and pools will succeed only if they are lit in an eye-catching way, are taken from a camera angle that highlights foreground vegetation, or have a riveting focal point.

The reflection of a rising or setting sun can add a colorful focal point to otherwise drab water. Without the sun itself, color from a dawn or dusk sky gives a painterly effect to water, which can be enhanced by using a graduated sunset filter. At times when there is no added color from the sky, an extra dimension may be needed to lift up a picture of water from an unexciting record to a memorable image. Look for floating lily pads, emergent water plants, or a portion of a submerged branch, tree trunk, or rock. Any one of these can be used as a fixed focal point. Each will allow you plenty of time to determine how best to frame a flat stretch of water containing one or more focal points by varying the camera angle or length of lens.

Adjacent trees—notably weeping willows, which have branches that hang down rather than reaching skyward—can be used to frame a pond in a way reminiscent of curtains framing a window. I have also used a horizontal branch of a waterside tree, even a deciduous one in winter, as a frame above a pond. Any frame helps provide a feeling of depth to a two-dimensional picture and lures the eye toward the scene beyond.

Before setting out, study a topographical map, checking for adjacent high ground to give you an elevated view of the water. Some reserves have platform blinds for

Right: White water lilies *(Nymphaea alba)* growing on lake framed by alder and willow trees, Surrey, UK, July. *Hasselblad 500 C/M, 150mm f/4 Sonnar lens, Ektachrome 64.*

My eye was drawn toward this small, circular patch of water lilies bathed in sunlight beyond the silhouetted lakeside trees. The calm water adds to the serenity of the early-morning midsummer scene.

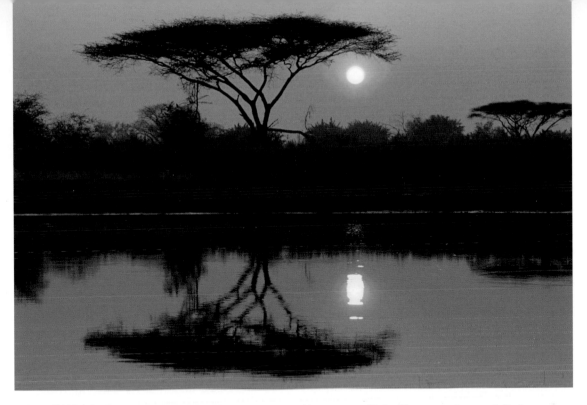

Above: Reflection of rising sun with acacia tree *(Acacia tortilis)* silhouette in pool, Duba Plains, Botswana, September. *Nikon F4, 80–200mm f/2.8 lens, Ektachrome 100S.*

At first light, the shallow pool looked unpromising, but as the sun rose above the distant trees, the water began to turn a faint pink, which soon intensified. I had a clear view between the horizon and the umbrella of the acacia tree for only a brief spell. A variation on this scene appears on page 118.

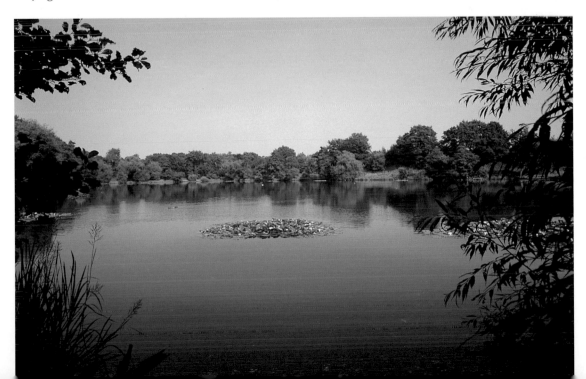

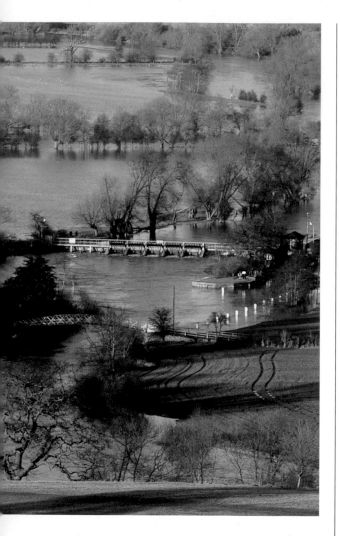

Flooded River Thames at Day's Lock from Wittenham Clumps, Oxfordshire, UK, February. *Nikon F4, 200–400mm f/4 lens, Ektachrome 100 Lumière.*

Calm floodwater can, on occasions, produce a compelling landscape picture. To get this scene of the flooded river and adjacent fields, I climbed a hill and used a long lens to crop out distant buildings. The crack willows lining the riverbanks and field boundaries lit by low-angled lighting late on a winter's day make the picture. Without the trees, the scene would have been a monotonous sheet of water, which I would have passed over.

unrestricted views over water. More than once, I have been glad I carried a stepladder in my four-wheel-drive to give me an overview of a pond or a lake. If I can position the vehicle in the right place, I can gain additional height by climbing up onto a custom-made roof rack.

Mobile subjects, such as waterfowl or mammals, which swim or move through water, will not wait for you to decide which viewpoint or lens works best. Rapid judgments must be made before either a subtle sky reflection fades in front of your eyes or animals disappear by submerging or moving out of frame. Even a colorful leaf floating on water may suddenly be blown against unattractive dead vegetation. Any one of these scenarios requires snap decisions coupled with instinctive reactions if you are to get successful photographs.

Ponds lend themselves particularly well to a long-term project. Using the same viewpoint to illustrate how the appearance of a pond changes with the seasons is an example of extended time-lapse photography. Another approach is to compile a photographic journal to record the succession of plants that flower and wildlife that visits the pond. These need to be documented at more frequent intervals, if not daily, maybe on a weekly basis.

As the days begin to lengthen in spring, marginal plants introduce patches of color as their flowers open. Gradually, the area of open water begins to shrink as small, floating plants such as duckweeds and aquatic ferns multiply and carpet the surface. Some of these make exquisite textured macro shots. In summer, rolled water lily pads break the surface, opening out into a haphazard arrangement of green dinner plates, making convenient platforms for frogs to rest on or allowing waterbirds such as coots and lily trotters, with their widely spaced toes, to literally walk over water. Come autumn, wind-blown leaves from

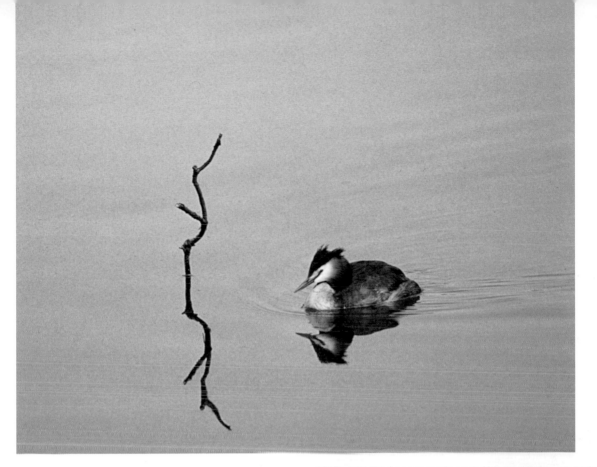

Great crested grebe (*Podiceps cristatus*) on pond at Kew Gardens, London, UK, May. *Nikon F4, 300mm f/4 lens, Kodachrome 200.*

This is a case of how less can be more. I chose not to use a polarizing filter, so that the pale sky reflection would completely blot out any submerged objects that might detract from the grebe and the twig. Together, with their reflections mirrored in the pallid water, they make a simple study that repeatedly lures the eye.

Water lily leaves and buds in pool, Beijing Botanical Garden, China, May. *Nikon F4, 80–200mm f/2.8mm lens, Kodachrome 25.*

The water lilies were so densely packed in this pool that the leaves were forced to grow up at angles from the water surface. This is essentially a unicolored picture—even the sepals of the flower buds are green. It was the textured undersides of the leaves that lured me to set up the camera.

deciduous trees introduce new color to the floating carpet, and if the water freezes over before the leaves have sunk, they become encapsulated in ice, offering exciting possibilities for outdoor still-life pictures.

Whenever I hear the word *pond,* I have a mental picture of a shallow, circular patch of water, which is quite illogical, since ponds come in a wide variety of shapes, sizes, and depths. Many are permanent, but some are temporary, filling only after heavy rain and remaining dried-out hollows for most of the year.

It is the permanent ponds that are the most rewarding for photography, since they support a wider variety of aquatic life, including water plants. Marginal water plants grow in clearly demarked zones, since each kind flourishes in a specific depth of water and peters out in deeper or shallower water, where it has to compete with plants better adapted to these depths. Where the depth is uniform throughout much of the pond, vigorous species such as water lilies or water crowfoot may dominate to such an extent as to appear a monoculture. This is not necessarily a disadvantage for photography, in that it presents some wonderful repetitive shapes and patterns on

the surface. It certainly helps if you can look down onto the surface for these kinds of shots, whereas emergent flowers can be taken from the bank using, if necessary, a long lens. More than once, not having a boat, I have been thankful I carried a long telephoto lens so I could home in on photogenic plants growing in water that was too deep for wading.

A pond in your own backyard can be especially rewarding if it is constructed with varying depths and native plants are introduced (either from seed or plants bought from specialist nurseries, *never* by digging up plants from the wild), which will encourage native wildlife. Within a year of constructing a series of ponds linked by cascades in our own Surrey garden in England, we had frogs and toads coming to spawn each spring and dragonflies emerging from their larval shucks during the summer months.

Having a pond on your own doorstep is a huge advantage, because you have no distance to travel to monitor the daily changes and to maximize on the photo opportunities. I keep a multiyear diary in which I note the date when each kind of animal first appears each year. This gives me information about the sequence of events in the natural world. Then, if spring comes earlier or later than usual, I have some idea of the succession.

Over the years, I have found the most productive way to photograph spawning

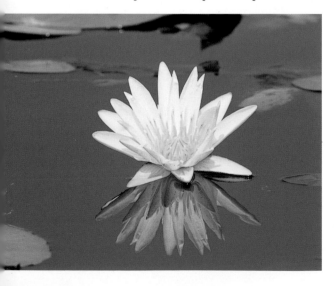

Water lily *(Nymphaea nouchali),* Duma Tau, Botswana, August. *Nikon F4, 500mm f/4 lens, Ektachrome 100S.*

As all the nearest flowers had been trampled underfoot by game coming to drink, I had to wade out into the water. Before I attached the camera with the 500mm lens, I made sure the tripod was securely wedged into the bottom of the pool.

Frogs *(Rana temporaria)* spawning in garden pond, Surrey, UK, March. *Nikon F4, 200mm f/4 Micro-Nikkor lens, Kodachrome 200.*

Each year frogs and toads converge on our ponds to spawn, but the weather is not always conducive for photography. The water surface needs to be calm, and preferably, the sun should be shining, so that a reasonably fast shutter speed can be used to freeze all movement of the frogs as they chase around after a mate. As I like to see a glint in the eyes and on the wet skin, I prefer not to use a polarizing filter.

frogs and toads is to use either a medium telephoto (such as 80–200mm) or a long macro lens (a 200mm or a 70–180mm macro zoom). Armed with a camping stool and a tripod, I can then sit beside the water and work for several hours. On seeing a person approaching the water's edge, the instinctive reaction of amphibians, whether spawning or not, is to duck down under the surface. But within a few minutes, a pair of beady eyes breaks the surface, soon fol-

lowed by many more. It is essential to refrain from making rapid movements while photographing, or the amphibians will submerge again. Before cameras were available with built-in motor drives, the sudden movement of a hand recocking the shutter would be enough to trigger the amphibians' escape reaction.

Somewhat later in spring, swallows and martins seek soft mud at the margins of puddles to gather for building their mud nests

55

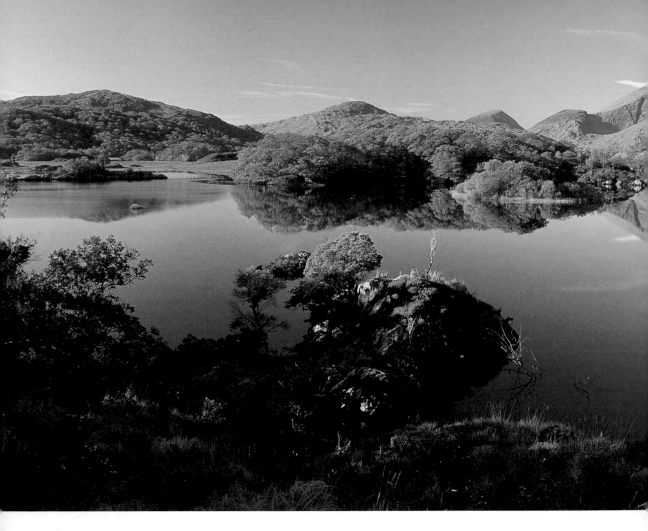

Lough Leane surrounded by Killarney oak woods, Ireland, November. *Hasselblad 500 C/M, 150mm f/4 Sonnar lens, Agfachrome 50S.*
A late-autumn Irish scene encapsulates the unique time when early-morning sun paints the mirrorlike calm water on a lake. No other time of day approaches this special short-lived moment.

beneath eaves. Once a favored place has been located, action pictures of the birds' coming and going are best taken using a vehicle as a blind.

Terrestrial birds will visit smaller ponds, especially those with shallow margins, to drink all year round. Even in a garden, they tend to be fairly wary and constantly look up to check for approaching predators. A long lens is therefore essential, and it may be necessary to work from a blind. A house with a window that overlooks a pool can be used as a permanent blind. Occasionally, wild ducks or even a heron may be attracted to a garden pond, but they rarely stay for long (see page 108).

Ducks, coots, moorhens, grebes, and swans are among the many waterfowl attracted to larger ponds to feed. Generally, birds on ponds or lakes adjacent to roads or within public parks and gardens become habituated to people and will tolerate a much closer approach than those on water bodies in wilderness areas.

Lakes

Expansive lakes, such as Lake Victoria in Africa and the Great Lakes astride the U.S.–Canadian border, are difficult to do justice with a single still picture. For this reason, I prefer more intimate lakes that are backed by steep hills with colorful rocks or trees, have a convoluted coastline, or have attractive clumps of trees nearby. Notable photogenic lakes include Mono Lake in California, with its emergent tufa formations; Crater Lake in Oregon; the English Lake District; and Lakeland in the South Island of New Zealand. Finland abounds in lakes, approaching two hundred thousand in total.

To gain inspiration and to learn the whereabouts of photogenic lakes (or any kind of habitat, for that matter), it is worth browsing through engagement and wall calendars or well-illustrated guidebooks. Take notes in the field when talking to other photographers, and look through magazines and books at the library. If you are really well organized, you can then collate the information onto a computer database under the relevant state or country. Then all you have to do when you are planning a visit to a particular area is to make a printout.

Reflections

Hills or mountains rising above calm water invariably produce a scene worthy of capturing on film, especially if they are decorated with an autumnal mantle or dusted

Hills reflected in Loch Tulla, Strathclyde, UK, August. *Nikon F3, 35mm f/2 lens, Kodachrome 25.*
The individual elements of this picture—the clouds, the hills, and the trees—are not particularly arresting. Yet their integrated colors and tones, as well as the undulating diagonal skyline, make a striking reflection in the near-calm water of the Scottish loch. This image is proof that the most memorable reflections often are among the simplest.

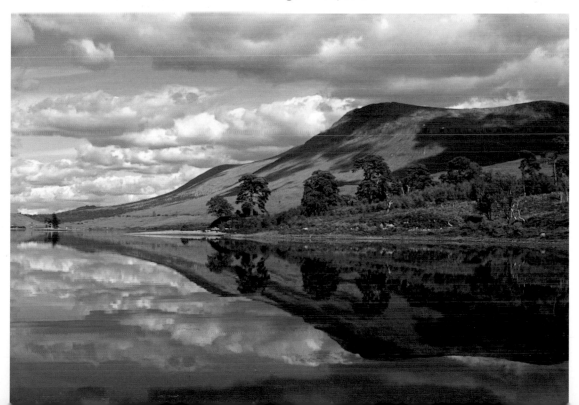

with snow set against a blue sky. The most perfect reflections usually occur early or late, the times of day when the air is most often calm. It is, therefore, no accident that many pictures in this section were taken in early morning. But though ripples created by wind or a rising fish can spoil a perfect reflection, they may produce some exciting abstract images. (see page 118)

Sometimes the reflection alone makes a picture. Since reflections are never as bright as an aerial image, the exposure then needs to be recalculated. To photograph the reflection, I usually need to open up a half stop on the metered exposure for the actual subject above the water.

Among the simplest reflections worth photographing are a few isolated aquatic plants emerging from clear water uncluttered with floating leaves. Look also for trees or plants growing beside or in the water and waterfowl or wildlife visitors or residents.

Long-legged birds such as herons and egrets, which rely on their guile by standing motionless for long periods waiting to catch their prey, are much more likely to be seen with their bodies mirrored in water than are ducks that are constantly on the move.

Mute swan *(Cygnus olor)* with reflection in Salcombe Estuary, Devon, UK, December. *Nikkormat FTN, 400mm f/5.6 lens, Kodachrome 64.*

The swan had been fishing for crabs, so I was already focused on the swan's head. As the bird dropped a crab, water dripped from the bill, creating the circular ripples. The white plumage provides an excellent contrast to the deep blue estuarine water. Fortunately, the low-angled winter light was beaming in toward the head of the swan so that the neck shadow fell along the back.

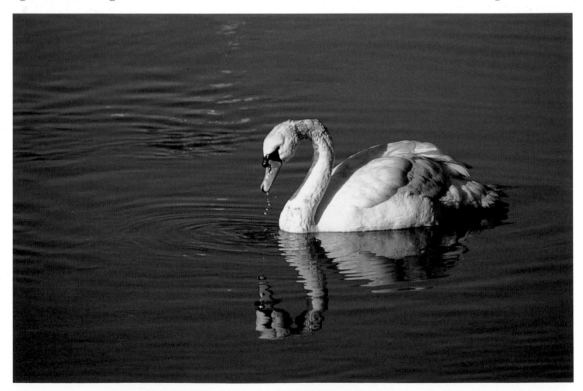

Raccoon *(Procyon lotor)* with reflection, Montana, June. *Nikon F4, 300mm f/4 lens, Kodachrome 200 (C).*

Any terrestrial animal that moves down to the water's edge to drink presents opportunities for taking a portrait with a reflection. Patches of grass on the bank gave me a good average tone on which to manually meter.

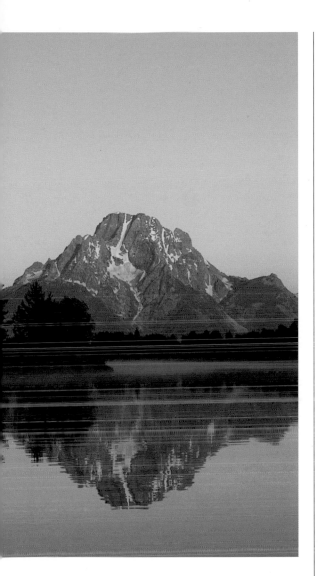

Mount Moran at dawn reflected in Snake River, Grand Teton National Park, Wyoming, July. *Nikon F4, 80–200mm lens, Ektachrome 100 Plus.*

Initially, both the mountain and the reflection appeared as a ghostly blue. Then, as the sky colored behind me, the top of Mount Moran became painted with a subtle alpenglow, which gradually extended down the mountain. Unlike my October shot (see page 36), I worked from the water's edge and zoomed in to fill a vertical format.

Azaleas and rhododendrons reflected in lake at Leonardslee Gardens, Sussex, UK, May.
Hasselblad 500 C/M, 150mm f/4 Sonnar lens, Ektachrome 64 with polarizing filter.

Whenever I visit a garden with an area of open water, I check out the reflections. Calm water often occurs early in the morning, and it was the diagonal line of the shrubs echoed in the water that attracted me. Notice how the reflections are not as bright as the actual plants.

Basic reflections, especially simple silhouettes, can be greatly enhanced by the ephemeral color of the surrounding water that occurs at first and last light. As long as the sun is not masked by clouds, these times of day rarely fail to disappoint, and they may turn out to be awesome experiences, although I have risen early or waited at the end of the day for these brief moments many more times than I have successfully pho-

tographed them. But you will not have a hope of getting the shot unless you are out there ready and waiting with film in the camera. The reflection of preglow or afterglow color can be very subtle. Minutes before the sun rises, drab water appears as though someone has painted a delicate diffuse pink wash over it. Gradually the color intensifies, and suddenly, as the sun rises above the horizon, it turns the water to liquid gold.

The advantage of working at first light is that, contrary to the end of the day, the light level is constantly improving. This allows for successively faster shutter speeds to be used for taking moving subjects. At dusk, when you need to work at the widest aperture possible, you have to either decrease the shutter speed or increase the film speed as the light continues to fail. For this reason, it is a good idea to use fast lenses and to have two camera bodies loaded with different speed films. If you have just one film speed, you can always increase it by "pushing" it one or more stops (see page 28).

The downside of a dawn shoot is that to be sure of catching the dawn preglow, you have to arrive on site while it is fairly dark. This makes it difficult to fully appraise the best camera angles. Ideally, you really need to check these out the previous day in better light, because you will not have time to relocate as the sun comes up.

For most of the day, calm water appears as a brighter than average tone; if you go with the in-camera reflected reading, it will result in underexposure. This is fine for silhouettes of birds or plants surrounded by colored water at dawn or dusk, but not for animals or scenics taken at other times of day. Then, either take an incident light reading with a hand-held meter or use the camera to manually meter an average-toned object lit in the same way as the subject.

Animals that spend virtually all day in water potentially offer more opportunities for photographing them with their reflections than do animals that make only brief sorties to water to drink. But even hippos, which spend all or most of the day in water, emerge only briefly to breathe, then often with such force that they disrupt the water surface, thereby ruining any chance of a reflection.

Moving Water

Babbling brook or raging waterfall, the sight and sound of moving water have a magnetic attraction for me, since it contributes a unique element to any wilderness area. Indeed, falling water is often heard before it is seen. Whenever I close my eyes beside a brook breaking onto stones, I could be anywhere in the world, so universal is the sound.

Waterfalls

Gentle falls that tumble over boulders and stones in a stream or river are known as rapids, a series of small falls becomes a cascade, and a steep drop in gradient generates a waterfall.

Most often, falls form as a result of differential erosion. The force of water falling over a hard, resistant rock layer undercuts softer sediments beneath. Also, where a river or stream meets a fault or a crevice, or a river becomes dammed, it has no option but to plummet. As a glacier moves through a valley, it cuts steep walls, and waterfalls plunge down the sides. Pounding action by surf erodes coasts to create cliffs over which water curtains drop as coastal waterfalls.

The topography, the rock type, the volume of water, and its velocity all determine the type of waterfall and the shape of the curtain. The simplest type of fall is a single narrow curtain formed when a stream plunges from a hard rock cap.

Closed falls in narrow valleys present few possible variations of camera viewpoints, whereas larger falls in more open situations offer many photo opportunities where both the camera position and the length of the lens can be varied.

High-volume rivers, especially when they are swollen with water from melting snow or glaciers, not only produce an awesome sound but also carve deep canyons. The powerful force of a vast, crashing curtain may cause the ground to vibrate underfoot and also tends to create considerable spray, which is both beneficial and detrimental to photographers.

On the plus side, if the sun is shining and you stand in a position between the sun and the spray, a rainbow will be visible. The bad news is that heavy spray blown horizontally toward the camera makes photography

Right: Victoria Falls from Zimbabwe, September. *Nikon F3, 28mm f/2.8 lens, Kodachrome 25.*

The volume and sound of water as it crashes over Victoria Falls are awesome. From ground level, the wide cataract presents many different viewpoints for photography. A high-volume fall always generates copious spray, so that when the sun beams onto it from behind the camera, a rainbow is guaranteed.

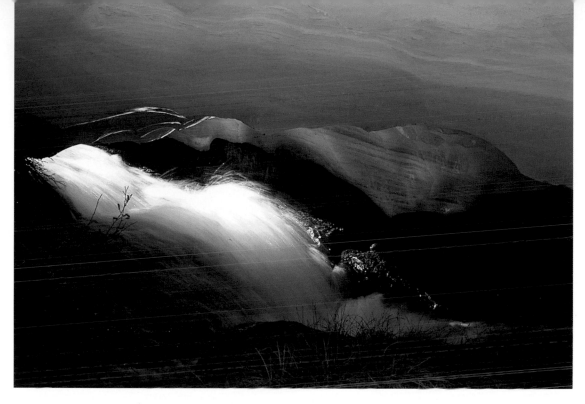

Above: A babbling brook cascades beneath an ice bridge, Greenland, July. *Nikon F4, 35mm f/3.5 lens, Kodachrome 25.*

 Metering this shot was tricky, with the water spotlit by a shaft of sunlight. I decided to meter off the blue ice above, knowing the water would be somewhat overexposed. However, a slow shutter speed has helped to reveal the streaked water.

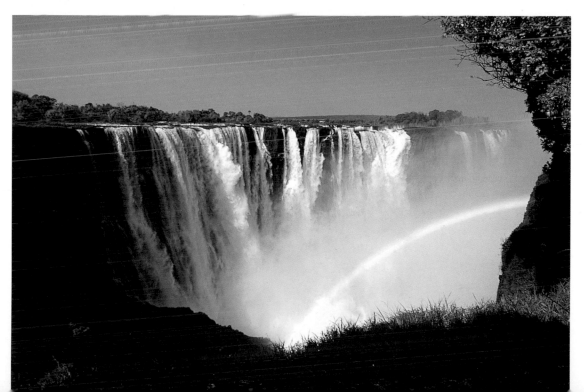

very difficult and is a potential risk for modern electronic equipment. An umbrella is not much use in this situation. A waterproof camera coat helps, and even a small towel wrapped around a larger lens can absorb fine spray. But you need to check repeatedly to see if any spray has reached the front lens element or filter, and, if necessary, wipe it clean.

As falling streams of water descend over a gently sloping rock face, they form a series of bifurcating cascading ribbons, which can be especially attractive when taken using a slow shutter speed so that they appear as soft-edged, fluid lines.

Few waterfalls are conveniently situated adjacent to the road, so it is most unlikely that the best photo opportunities will occur from a chance encounter. Many tourist maps now mark waterfalls, but unless you have seen a picture, there is no way of knowing whether they are photogenic. On a sunny day, the aspect of the falls will determine the optimum time for photography; you need to avoid contrasty lighting with a mix of direct sun with bright highlights and strong shadows within the frame. When water is the main point of interest, it is preferable to work early or late in the day, before the falls are lit directly by sun, or,

Hraunfossar on Hvita River in Iceland, July. *Nikon F4, 80–200mm f/2.8 lens, Ektachrome 100S.*
This is just a small portion of a broad waterfall (see page 26) that discharges into pale blue glacial water. Although a panoramic format would have shown more of this uniquely wide falls, greater detail of a portion is possible with a longer lens. I love the way streams suddenly appear from the willow-covered hillside, flowing around the mossy-edged islands.

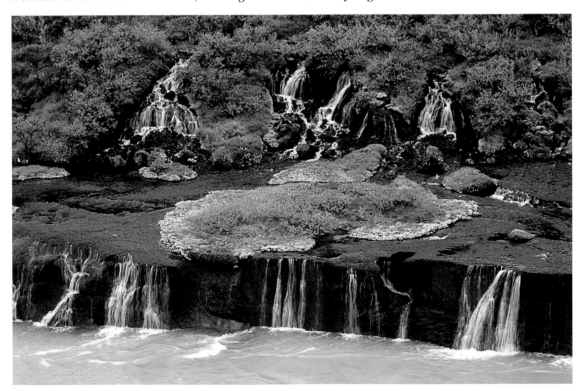

better still, to work on an overcast day using the even lighting produced by a complete cloud cover. A drab, colorless sky adds nothing to the composition and needs to be either cropped or enhanced with a naturalistic-colored (preferably gray) graduated filter. On the other hand, when photographing falls within a broad landscape vista, a sunny day with blue sky is preferable for the whole scene.

It is always worth asking rangers or local people for locations of remote and less popular falls. These may involve a hike, but you will have them all to yourself. Remember, too, that the impact of a waterfall is dependent on the volume of flow, which can change quite dramatically not only with the seasons but also from one week to another. Waterfalls that are fed solely with rainwater may dry out during periods of drought, whereas glacier-fed falls have heavier flows in warmer weather, as the ice is melting.

Coastal waterfalls that plunge directly into the sea are not so readily accessible as inland falls. In places where there is a good tidal range, I prefer to photograph such falls by walking onto the shore at low tide so I can use a tripod. Make sure you allow enough time to retrace your tracks before the tide turns and cuts off a safe passage. Where the land falls away sharply into the sea, you will often have no option but to work from a boat.

There are many ways to photograph a waterfall, and the decision will be determined by the location and size of the fall. Thin waterfalls with a long drop will tend to dictate a vertical composition, whereas broad falls are better suited to a horizontal or even a panoramic format. The choice of lens may depend on how close you can safely stand without a naked camera being showered by spray and whether the falls are out in the open or within a forest. Over the years, I have used every focal length I possess, from 20mm to 500mm, to photograph waterfalls. If a view is partially

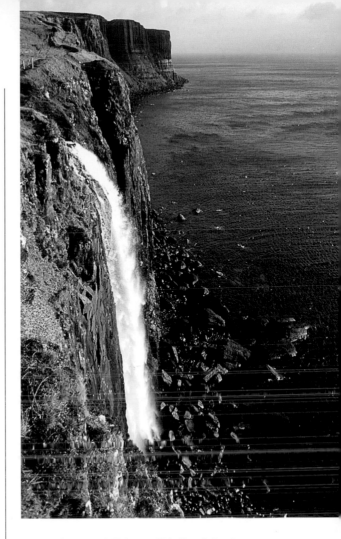

Coastal waterfall from Kilt Rock lookout, Isle of Skye, UK, June. *Nikon F4, 20–35mm f/2.8 lens, Ektachrome 100 Lumière.*

A heavy rainfall all day helped increase the volume of this narrow coastal waterfall, which was spotlit by late-evening sun. To take this shot, I had to lean out toward the sea from a scenic overlook. The narrow, linear falls dictated a vertical format.

blocked by trees or rocks, I use a long lens to extract a portion of a bifurcating waterfall for an abstract design.

Whether you should use a slow or a fast shutter speed depends on the volume of water and the quality of light. A slow shutter speed transforms a small flow into an

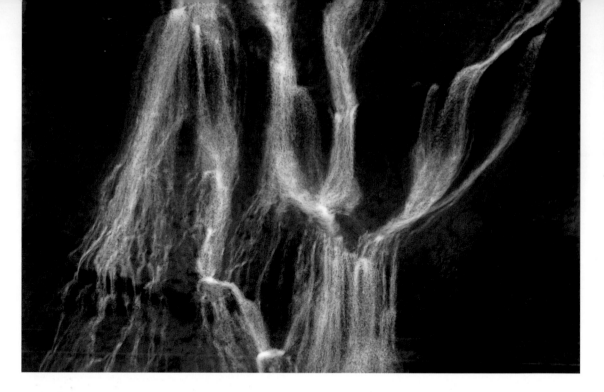

Multiple exposure of bifurcating fall flowing down black basalt rock, Hraunfossar, Iceland, July. *Nikon F4, 300mm f/4, Ektachrome 100S rated at ISO 1600.*

This frame illustrates how the appearance of moving water changes when many fast exposures of a moving subject are made on a single frame. I uprated the film speed to ISO 1600 and took sixteen exposures on one frame, which resulted in an almost granular appearance of the water against the dark rock.

ethereal, translucent curtain through which the rocks behind are visible, yet renders a large volume of water as a solid white area. Try using successively slower shutter speeds to gain different degrees of blur. Making a Polaroid print on the spot is a very useful way of checking the effect of different shutter speeds. For example, a 1-second exposure will coalesce all water movement into a smooth, soft-edged, silky curtain. Although this is not the way we see falling water, it can be an effective way of depicting a waterfall.

Essential items for making a creative blur picture include a slow-speed film, a sturdy tripod, a cable or electronic release, and on sunny days, a gray neutral-density filter, which can reduce the exposure by one, two, or even three stops.

Multiple exposures on a single frame are another effective way of depicting low-volume falls. If you uprate the film speed, each exposure will underexpose the film, until ultimately it builds up to the correct exposure. This technique works only if you have a camera that has some mechanism to prevent the film from advancing.

Another decision is whether to frame a waterfall face on, from the side, or even from behind. Waterfalls that repeatedly bifurcate as they hit a rock face need to be taken from the front, as do falls set far back in narrow clefts. Falls that spill over the lip of a hanging valley, dropping through the air as a free arc, often work well when viewed from the side. Walking behind a waterfall will give you a novel viewpoint, setting the white cascade against a blue sky.

Landscape photographers generally favor low-angled light at the beginning and end of the day, because it creates long shadows that accentuate vertical elements within a horizontal scene. But with the exception of waterfalls that face the rising or setting sun, these times of day are the least suitable for photographing vertical structures. Open falls experience better lighting for much longer periods of the day than closed falls

Godafoss, the "Falls of the Gods," Iceland, July. *Hasselblad 501 CM, 80mm f/2.8 Planar lens, Ektachrome 100S at midnight.*

At high latitudes, where it never gets dark during the summer, it is possible to photograph around the clock. This picture was taken at midnight a few hours after I arrived in Iceland. Low clouds forced me to crop in tightly to the top of the horseshoe-shaped falls. Using the TTL meter in my Nikon, I metered off the white water and opened up two stops. The 1-second exposure has resulted in a wonderful silky appearance to the moving water.

in narrow clefts, which need to be photographed either when they are frontlit by the sun (for south-facing falls in the Northern Hemisphere, this will be around the middle of the day) or at any time by soft, indirect light in overcast conditions. During the summer months in high-latitude locations, when enough light persists for photography twenty-four hours a day, midnight shoots can give you a wonderful soft light without the hassle of people walking into the frame at popular tourist spots.

Clear viewpoints of waterfalls within forests are limited, and often the only camera angle without distracting branches cutting across the frame will be from the riverbed itself. Whenever I venture into a river, I do so with caution, leaving all my gear on the riverbank while I check out the depth of the water and strength of the current. Shallow water without a strong current presents no problems, but it is pointless and

foolhardy to set up a tripod in a raging torrent. At best, your pictures will be blurred from the persistent pounding of the water against the tripod legs, and at worst, you may lose a camera. Once I find a viewpoint I like, I return for a tripod, which I firmly anchor in the riverbed before attaching the camera. I carry extra lenses, filters, and films in a waist pouch. Using this wading bag saves me valuable time, as I do not have to return repeatedly to the bankside for forgotten items. In cold water, fishermen's hip-high waders are a must if you are to survive immersion for more than a few minutes.

I am always on the lookout for additional color to add interest to my waterfall pictures. A waterfall that has a gentle gradient and tumbles over rocks may be enhanced by moss-covered stones in the streambed or flowers nearby. Where streams or rivers—even fast-flowing ones—plunge past deciduous trees, the water can be framed by fresh green spring leaves or glowing autumnal ones.

Open falls that generate copious spray will create a striking rainbow when the sun is shining on your back. If you see pictures of falls with a rainbow, try to find out from the locals when and where a rainbow is most likely to be seen, for the position will vary with the time of day and the season, as the sun's angle relative to the spray changes. The window of opportunity may be quite small.

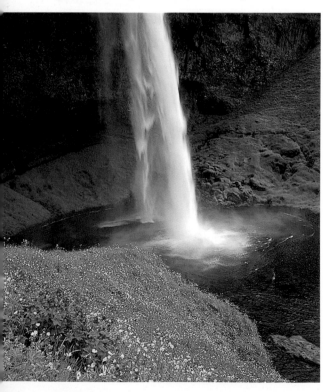

Buttercups and wood cranesbill frame Seljalandsfoss and plunge pool, Iceland, July. *Hasselblad 501 CM, 80mm f/2.8 Planar lens, Ektachrome 100S.*

Having initially photographed the fall from the opposite side, I walked around the path behind it so I could stand above the patch of wildflowers to add color to the foreground. I protected the camera from the persistent rain by holding an umbrella over it.

Aerial view of braided river, North Slope, Alaska, July. *Nikon F4, 50mm f/1.8 lens, Kodachrome 200.*

While I was photographing for British Petroleum on the North Slope, I was offered a helicopter ride. The best part of the trip was the spectacular view of a braided river. As the streams change course by crisscrossing the gravel outwash plains, they make a wonderful abstract image.

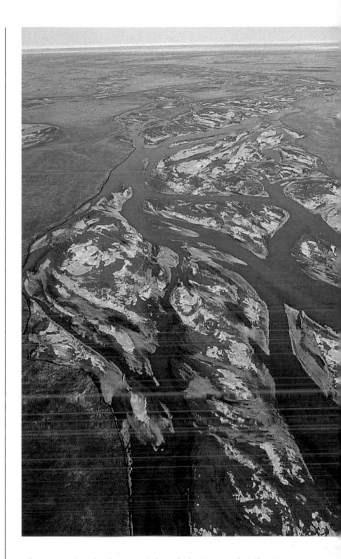

A single photograph taken from the ground rarely does justice to vast, broad-fronted falls, such as Africa's Victoria Falls or North America's Niagara Falls, unless it is a panoramic one. It is best to photograph such falls from a small plane. Before you get airborne, remember to load up with fresh film, and preferably take two camera bodies, because it is a waste of time loading film on a short flight. Also take a lens hood to reduce the risk of flare from the sun shining directly on the lens. A fast prime lens will allow faster shutter speeds than a slow zoom, and taping the focus ring set at infinity will avoid any chance of accidental shift of focus.

Before going out in the field to photograph waterfalls, check out postcards of famous falls that are much photographed to get ideas of viewpoints. Then try to frame your pictures to make original compositions.

Rivers

Streams and rivers are the lifeblood of the land. Both in their waters and along their margins, specialized communities of plants and animals have evolved.

Rivers have shaped the landscape over the eons. Raging torrents carrying boulders gradually cut through rock to form V-shaped valleys; slow, meandering rivers deposit silt on the floodplains. Glaciers are rivers of ice that move, albeit slowly, scouring distinctive, U-shaped valleys in their paths. The meltwater from the snout of a glacier is laden with debris, which is dumped to form the characteristic criss-crossing, braided rivers found in Alaska, Iceland, and Greenland. Because of the dynamic nature of these rivers, they provide wonderful fluid graphic designs. Smaller rivers that twist and turn as they weave their way around boulders are always a photographic challenge.

After a river has plunged down a waterfall, the vertical element to a composition is lost, so that ways and means have to be found to add interest to what is essentially a horizon-

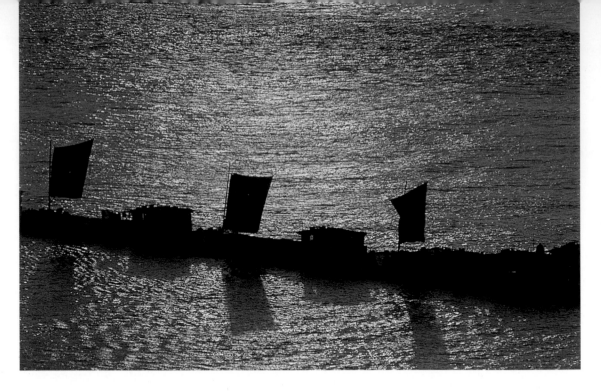

Junks on Yangtse, Nanking, China, October. *Nikon F3, 180mm f/2.8 lens, Kodachrome 25.*
The vast size of the Yangtse makes it difficult to depict in a single frame. When I spotted a line of junks downriver and the sun approaching the horizon, I knew I had a potential picture. By using a medium telephoto lens, I cropped in on a portion of the river that appeared as liquid gold and used the silhouetted junks as the focal point.

tal ribbon of water weaving through the landscape. Where a river flows through karst scenery or is backed by impressive mountains, peaks can add a valuable vertical element behind it. Once a river reaches the plains and begins to meander through a flat landscape, a high viewpoint is needed to capture the pattern it makes.

As with calm water, the color of a river's surface changes with the time of day, the angle of the sun, and the sky color. Sun can transform the dullest of water into a river of gold.

One of the most memorable dawn river shoots I have experienced was near Guilin in China. Some Chinese photographers persuaded me to stay in a very basic Chinese lodging place beside the photogenic Lijiang. Rising well before dawn, we took a boat upstream before climbing a hill overlooking

the river. The sunrise was subtle. As a pale pink glow appeared in the sky it became mirrored in the water below. While I was focusing my camera, I commented on how lucky we were to have a bamboo raft appear in the foreground at precisely the right moment (right). My hosts beamed; it had completely escaped my notice that we had towed the raft behind our boat.

The color of the actual river water is also highly variable. It may be crystal clear or tea colored from peat-stained bog water or tannins leaching from tropical forests. The degree of transparency or turbidity of water affects the type of picture that can be taken. Clear lowland rivers in which submerged aquatic plants thrive are greatly enhanced by using a polarizing filter to remove skylight reflections. The colors and shapes of submerged rocks or vegetation then become

apparent. If the water is shallow, I wade into the river for through-water shots; otherwise, I look for a bridge on which to set up my tripod for an elevated viewpoint.

As a fast-flowing river tumbles over boulders and stones, it comes to life when viewed in direct sunlight. Wherever the sun is reflected off the bubbling water, a myriad of highlights appear, not unlike the way a gemstone glistens under a bright light when it is turned in the hand. A fast shutter speed records these reflections as a series of small, bright highlights, whereas a slow shutter speed abstracts them into a series of haphazard white scribbles snaking their

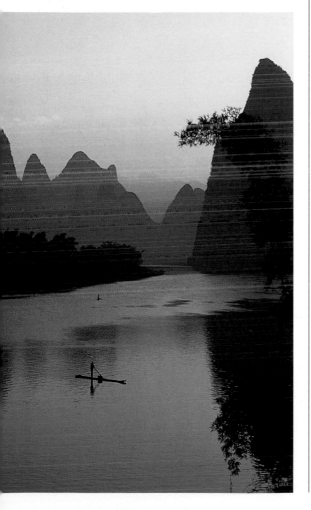

way around the obstacles. A slow shutter speed can also be used to capture bright autumn leaves as streaks of color as they rotate in eddies or float downstream.

Smaller rivers that have a lush mix of flowers and ferns along their margins look especially attractive when framed to include their verdant banks. Narrow water stretches can be taken from one bank looking across to the other, but if a stream is shallow without a strong current, I may decide to wade out into the water, always making an initial exploration without a camera.

After a long period of drought, without being fed by snowmelt, levels of rivers can fall substantially. Then, intriguing eroded shapes of bedrock may become exposed, providing some ephemeral riverscapes depicting the interaction of water with the rocks.

Coastal Features

As waterfalls add height to a river, so waves add height to the sea. Factors affecting the height of waves include the force of the wind and the distance it has blown across open water (the fetch). As a wave moves up the shore and hits the bottom, the height increases, and it eventually breaks. The spectacular curving breakers sought by surfers are more dramatic, especially when a breeze whips up water on a backlit crest.

Since seawater is highly corrosive, avoid any risk of salt spray blowing onto an unprotected camera by maximizing the working

Lijiang at dawn, near Guilin, China, October. *Nikon F3, 50mm f/2 lens, Kodachrome 25.*

Local knowledge helped me achieve this picture, beginning with a boat ride before dawn and a climb up a hill for a high vantage point of the photogenic Li River. The color, although subtle, complements the spectacular karst backdrop, with the bamboo raft providing a focal point in front of the silhouetted giant bamboos.

River Itchen, Hampshire, UK, June. *Hassel-blad Superwide (38mm), Ektachrome 64 with a polarizing filter.*

The crystal clear waters of this chalk stream were perfect for taking a wide-angle shot of the submerged water crowfoot and starwort plants. Standing on a bridge beside the river, I used a polarizing filter to remove the skylight reflection in the foreground.

distance when at the coast on a windy day. Down on the beach, use a long telephoto lens, and shoot at an angle to the waves.

Metallic nonanodized tripods are susceptible to corrosion from seawater. Protect the base of the legs from coming into contact with wet sand or seaweed by wrapping each in a tough plastic bag secured with a rubber band. Wooden tripods are ideal for working along the coast, as they present no such problems.

A safer viewpoint for photographing the coast is up on a cliff top, but a high angle will not give such a dramatic camera angle for breaking waves. It is nonetheless a good vantage point for an overhead view of the surf pattern breaking on a beach.

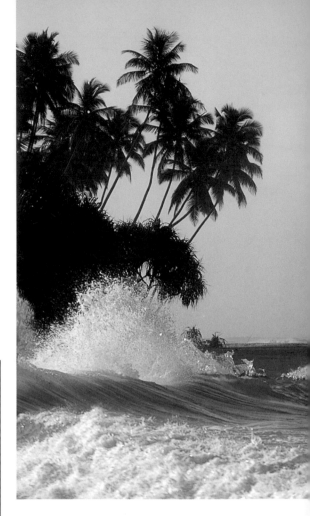

Wave breaking beneath coconut palms and screwpines, Koggala Beach, Sri Lanka, May at dawn. *Nikon F3, 400mm f/5.6 lens, Kodachrome 64.*

A long telephoto lens is essential for capturing a tight crop of a breaking wave without risking a drenched terrestrial camera. I particularly like the sudden change from a curvaceous sheet to an explosive burst as the wave breaks onto the shore.

Blowholes arise on exposed coasts as the sea constantly pounds through rock fissures in the ceilings of caves. When the incoming tide surges into a cave with a blowhole, a white plume of water spouts geyserlike through the hole. A polarizing fil-

ter will help increase the contrast between the white spout and a blue sky and also enrich the sea color, especially so with tropical turquoise lagoons.

Cascades and Fountains

Moving water—whether it be a rippling stream, a cascade, or a fountain—adds a special quality to any garden, large or small. In hot climates, fountains and water chutes not only have aesthetic value but also help lower the ambient temperature in enclosed courtyards.

Early in the seventeenth century, formal cascades known as water-staircases were created in Italy. The sole early formal

Informal cascade at Bowood, Wiltshire, UK, June. *Hasselblad 500 C/M, 150mm f/4 Sonnar lens, Ektachrome 64.*

Designed by Charles Hamilton in a rococo style in 1785, this cascade looks remarkably naturalistic. A 1-second exposure caused the motion of the tumbling water to blur into silky, white lines.

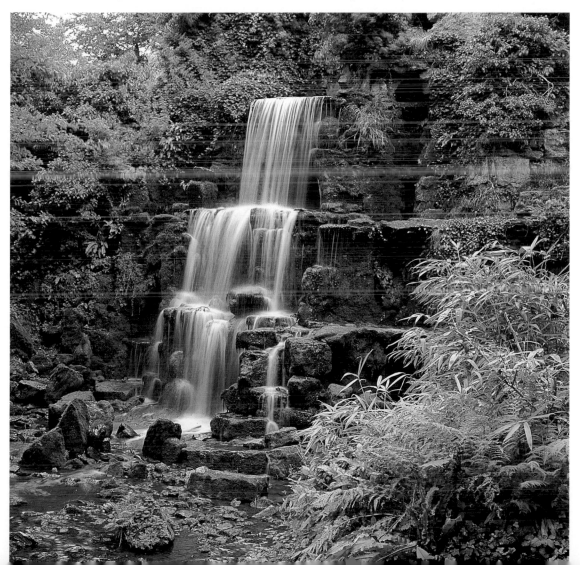

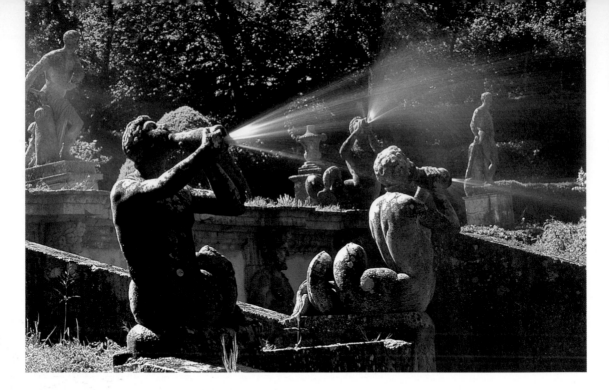

Jets emerge from tritons with shells, Jardin d'Albertas, Aix-en-Provence, France, April. *Nikon F4, 35mm f/2 lens, Kodachrome 25.*

I was fortunate to visit this eighteenth-century garden as it was undergoing restoration, when the water was turned on specially for photographing early in the morning. A slow shutter speed and natural backlight helped enhance the fine water jets, which illustrate a highly creative use of moving water in the garden.

cascade to survive in Britain can be seen at Chatsworth in Derbyshire. When "Capability" Brown began to make expansive landscaped gardens in England, creating new lakes by damming watercourses, informal cascades became the vogue. Boulders strategically placed on a slope of a cascade encouraged the water streams to bifurcate as they do in nature.

The camera angle for vertical fountain jets, as for geysers, needs to be critically appraised, as a white jet will disappear against a white sky. A low camera angle will help to set off jets against a blue sky, which can be enhanced by using a polarizing filter.

Backlit jets look dramatic when viewed against a dark, unlit backdrop of somber conifers or a hillside in shade. Horizontal jets are best photographed from the side to reveal complete arcs.

Nocturnal water displays with colored lights offer great opportunities for taking novel moving-water photographs. Here a tripod is essential for the obligatory long exposures. Since the water jets constantly rise and fall, it is impossible to manually meter the light, and this is one of the rare occasions when, having selected the aperture, I let the camera select the shutter speed using matrix metering.

Frozen Water

Frost, ice, and snow bring a special magic— as well as their own unique problems—to the photographer. The overnight transformation of a bleak landscape into a white winter wonderland is surely one of nature's miracles. And frost adds a fairyland touch to many a dormant landscape.

Preparing for Freezing Conditions

It pays to be prepared to rise early to ensure that you do not miss out on ephemeral frosty conditions and pristine snow-covered landscapes. My preparation begins the night before, when I listen to the weather forecast.

Knowing that cold can mean death to batteries, I either reload all camera bodies with lithium Energizer batteries guaranteed down to –4 degrees F (–20 degrees C) or use a remote battery pack. Though the polycarbonate bodies of modern cameras do not

Rimlit snow-covered ridges at Artist Point, Yellowstone National Park, Wyoming, January. *Nikon F4, 135mm f/2.8 lens, Ektachrome 100 Plus.*

My visit to this popular overlook in Yellowstone on a winter's afternoon was most rewarding. There were few other visitors, and the sun outlined the ridges to perfection. The ridges and the trees provide a study in horizontal and vertical lines.

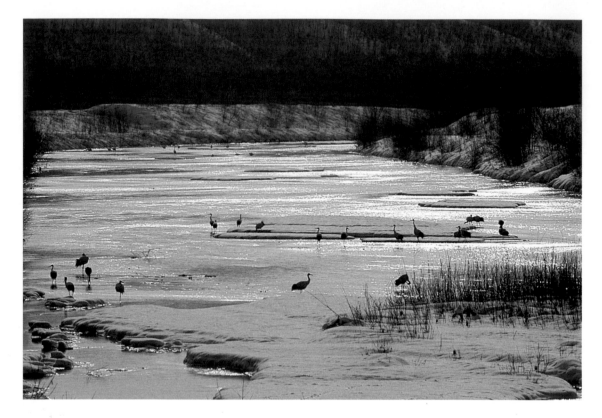

Manchurian cranes *(Grus japonensis)* waking up from roost site in river, Hokkaido, Japan, January. *Nikon F4, 600mm f/4 lens, Kodachrome 200.*

I was well prepared for this shot, with Tri-Pads covering my tripod legs and camera coats on both Nikon bodies. But with a temperature of –13 degrees F (–25 degrees C) at first light, the Energizer batteries failed to function after a short spell. So I alternated camera bodies, keeping one warm inside my arctic anorak while using the other.

conduct the cold as much as metallic bodies, I find that it is helpful to insulate my Nikons with made-to-measure camera coats. I make mine from a double layer of acrylic fleece, using Velcro tape for quick release when a film change becomes necessary. I also winterize my tripod legs by covering the cold metallic tubes with leg wraps, the Tri-Pads made by A. Laird. Each consists of an internal foam tubing, cut lengthwise, with a water-resistant nylon cover secured by a Velcro strip. Alternatively, strips of foam lagging (used by plumbers to insulate pipes) can simply be taped around the legs.

Finally, I set my alarm early enough to allow time to defrost the car windshield, so I can set out while it is still dark and be on site at first light before the sun melts away the frost fantasy.

If it is going to be really cold, stock up with chemical hand warmers, available at outdoor recreation and mountaineering shops. I wear a thin pair of silk gloves beneath padded gloves so I can slip a hand warmer between the two. Also, since I can-

not change films when wearing thick gloves, this gives me some protection when I remove the outer gloves to reload. When working in extremely cold conditions, be very careful not to let any bare flesh come into contact with frozen metal objects, since they tend to bond together. In severe cold weather, I also tape a hand warmer around the battery pack of my Nikon F4 bodies beneath the camera jacket.

Other problems arise when working at temperatures well below freezing. Film tends to become brittle, and the sprocket holes of 35mm films easily tear unless film is carefully rewound manually. This may take a little longer than using an auto rewind, but it is a wise precaution if you are not carrying a changing bag for opening the camera without risk of fogging the exposed film.

Polar bear *(Ursus maritimus)* cooling down on ice, Cape Churchill, Manitoba, Canada, November. *Hasselblad 500 C/M, 250mm f/5.6 Sonnar lens, Ektachrome 64.*

After being forced ashore as the sea ice breaks up in summer, polar bears relish the return of freezing conditions. Here a bear is enjoying a chance to cool off by lying spread-eagled on the ice. As both the fur and the ice were brighter than average tones, I spot-metered off the shadow area.

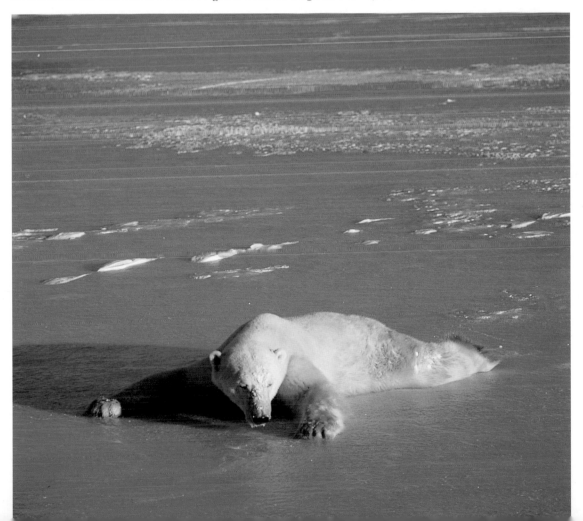

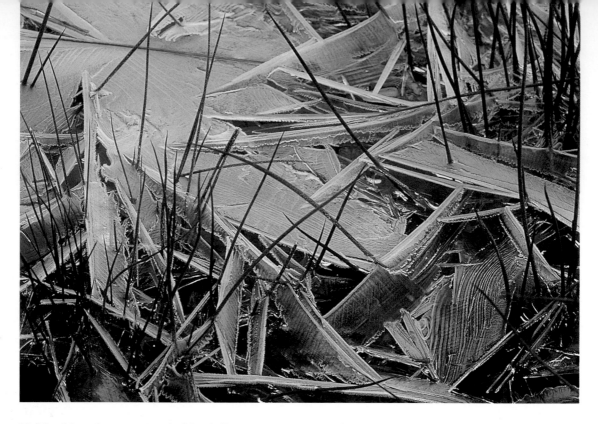

Uplifted ice sheets stranded by falling water levels in flooded fields, Sussex, UK, January. *Nikon F3, 135mm f/3.5 lens, Kodachrome 25.*

Alternating freeze and thaw conditions had resulted in thin ice sheets stranded high and dry as water in the flooded fields began to drain away. Initially disappointed not to find any water-fowl, I soon became absorbed in searching for different compositions among the angular ice sheets and emergent reeds.

Frost and Ice

The most striking frosty landscapes occur when tiny water droplets in freezing fog are supercooled so that they encrust every surface with ice crystals. When the air is still, rime forms equidistantly all over an object, whereas a steady wind causes long, dagger-like ice formations to build up on one side of leaves and branches. Hoarfrost, on the other hand, forms as water vapor condenses from the air at a temperature below 32 degrees F (0 degrees C). These ice deposits typically have a crystalline appearance and can look like exquisite feathers or ferns on glass.

Leaves or fruits encased in frost can add color to frost pictures. For this very reason,

I grow several plants in my garden with colorful leaves or fruits that persist well into winter. If I have to rise early before the sun melts the encrustations, at least I have no distance to travel!

As water drips from branches, down rock faces, or from overhangs and begins to freeze, icicles form. These increase in size when freezing conditions alternate with brief thaw periods. Where icicles develop from large rocky overhangs or cave entrances and it is possible to stand behind them, they can be used to frame a picture.

When backlit by the sun, icicles come to life with an inner glow, and glints appear around their margins. Even on an overcast day, this effect can be achieved by backlight-

ing with a flash. All you need is a good length of flash extension and a spiked pole topped with a flash shoe connection or an assistant to hold it in position. In either case, look back along the line from the flash toward the camera to check that it will not shine directly into the lens, thereby causing a flare.

If low temperatures persist, shallow ponds begin to freeze over, then increasingly larger water bodies, and even moving water. Glistening, snow-free ice functions as a most effective mirror, reflecting any animals that walk over it, as well as colorful dawn and dusk skies. Moving water freezes first along the margins of watercourses, until ultimately they become solid. In high-latitude locations such as Alaska and Iceland, large waterfalls can freeze in winter, making for dramatic

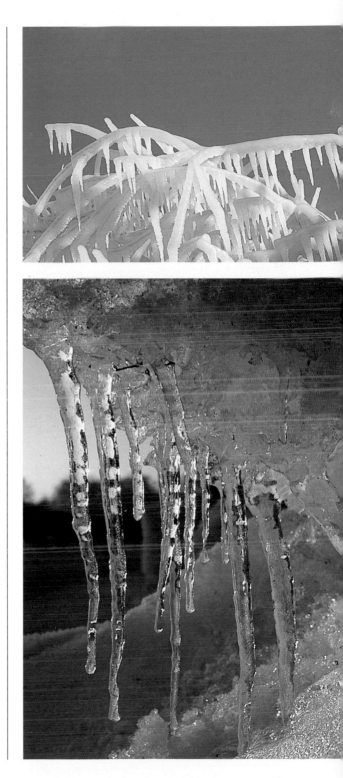

Man-made "ice trees" in Harbin, China, February. *Nikon F4, 80–200mm f/2.8 lens, Ektachrome 100S.*

In recent years, as more tourists have become attracted to Harbin, China's ice city, to see the ice sculptures (see page 83) public places are decorated with icicles by spraying water onto bare branches pushed into the ground. As subfreezing temperatures persist for several months during the winter, the "ice trees" make attractive naturalistic decorations. I metered for the sunlit icicles by turning around 180 degrees and manually metering off a dull gray concrete slab also in the sun.

Roadside icicles, Hampshire, UK, January. *Nikon F3, 105mm f/3.5 Micro-Nikkor lens, Kodachrome 25.*

As is so often the case with my close-ups, I come across them by chance while photographing other subjects. I had stopped to capture a view along a country lane, when I noticed the sun glinting on icicles hanging down from a roadside snowbank. These were gradually formed at night in temperatures just below freezing after a gentle thaw each day.

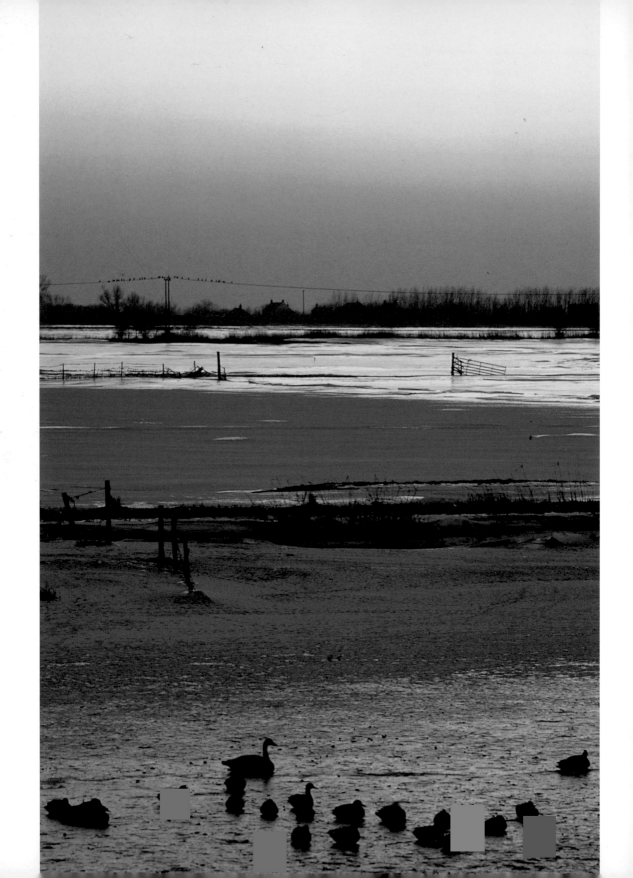

Right: Water on sea ice in Antarctica, December. *Nikon F4, 80–200mm f/2.8 lens, Ektachrome 100 Plus.*

When traveling at high latitudes in an ice-breaker, one has many opportunities for photographing different forms of ice. As our ship cut through a thin layer of sea ice, water and rectangular portions of ice slid over the frozen sheet, forming curious yet beautiful white patterns against a midnight blue sea. In a similar way, as surf breaks on a beach, the design within each frame is unique.

and unusual pictures. A novel way of photographing a frozen waterfall is to walk behind it and shoot through the ice curtain.

Before I left Britain's shores, I naively thought ice was the same the world over—clear as in our ponds or the ice cubes in our drinks. In fact, floating ice, which can originate from rivers, lakes, glaciers, or the sea, comes in a variety of colors, ranging from white, blue, darkly streaked with debris, to almost completely black from deposits of volcanic ash, and also takes a variety of forms. Steaming south in an icebreaker to reach emperor penguin rookeries, I saw not only towering tabular icebergs but also distinctive rounded pancake ice, irregular pack ice, and the curious grease ice that gives the

Left: Silhouetted wildfowl roosting on frozen flooded fields lit by afterglow, Ouse Washes, UK, January. *Nikon F4, 200–400mm f/4 lens, Kodachrome 25.*

After spending an entire day working from permanent blinds, I was rewarded as the sun set below a clear sky suffusing it with a wonderful pink afterglow. For a few brief moments, this color was reflected on the ice-covered fields. In fading light, with a slow-speed film, I was forced to use a slow shutter speed, but I lost only a few frames when the swan moved during the exposure.

sea surface an oily appearance. Small pieces of floating ice, usually from glaciers, are appropriately referred to as "bergy bits."

Among the most exquisite ice forms for photography are the blue bergs that appear in some parts of the Antarctic. Accessible ledges are eagerly sought after by opportunistic penguins. Smaller bergs appear in a variety of shapes in glacial lakes, where they originate in warmer weather as chunks of ice break away from the snout of a glacier. Accessible lakes decorated with blue icebergs include Jökulsárlón in Iceland, and Mendenhall and Glacier Bay in Alaska.

Ice absorbs all the colored wavelengths of white light except for blue, which is reflected. The reason why ice cubes appear colorless to our eyes is that the intensity of the blue light reflected from a small mass of ice is not vivid enough for our eyes to perceive.

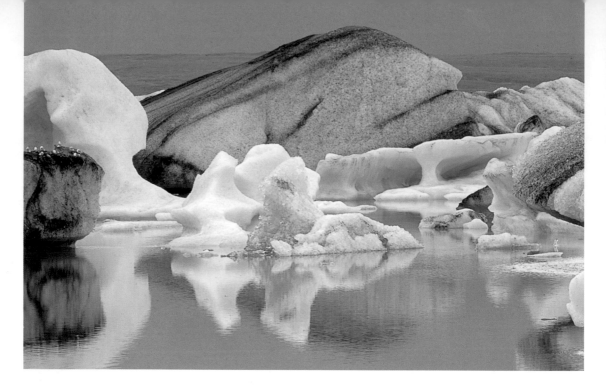

Icebergs in Jökulsárlón, a glacial lake at the foot of Breidamerkurjokull Glacier, south Iceland, July. *Nikon F4, 300mm f/4 lens, Ektachrome 100S.*

The shapes and colors of the icebergs in this glacial lake are so varied that they present endless scope for pictures at different scales. The black bergs arise when volcanic ash falls on the glacier. The blue bergs look most intense after rain on an overcast day, as here.

Icebergs appear blue when the intensity reaches a threshold that our eyes are able to detect. Large blocks of clear ice, as well as freshly exposed ice, tend to be blue. This can be seen when an iceberg capsizes and upturns to reveal the deep blue underside. As the top of an iceberg melts, the base rises and appears distinctly blue compared with the white top, which has been exposed to the sun. But it is not simply a matter of size that conveys the blueness to our eyes, for many huge bergs are white. These contain air bubbles and cracks, which disperse, refract, and reflect light so that the ice appears white. When rain falls and infills the cracks, the ice appears blue, albeit a less intense shade. Thus, in this case, photographing icebergs on a wet day is a bonus rather than a disadvantage.

The constant erosion of exposed ice by warmth from the sun and wave action results in some wonderful abstract, and even anthropomorphic, ice sculptures, which can be separated from neighboring bergs by using a long telephoto lens. In calm conditions, the shapes are mirrored in the water, their color changing with the time of day. Whenever I find an ice arch, I check all possible camera angles to see if it can be used to frame other bergs. Alpenglow transforms white bergs and arches into subtle pink and peachy hues, which add a feeling of warmth to the cold ice.

Like white clouds, white icebergs or ice-covered trees look dramatic when photographed against a blue sky. The contrast can be further enhanced by using a polarizing filter. A colorful dawn or dusk sky also makes a striking background.

In high-latitude locations, which are guaranteed to have prolonged freezing conditions, ice fountains and ice sculptures come into their own. However, only fountains that have been specifically designed to withstand the weight of accumulated ice layers can safely be allowed to freeze.

Northeast of Beijing, China, lies Harbin, where the traditional ice festival, banned during the Cultural Revolution, has been revived. When I first visited Harbin in 1987, isolated sculptures dotted a park. Eleven years later, they were much more elaborate, with a replica of the Great Wall snaking through the displays. The designs for the sculptures are drawn up on paper and created from huge ice blocks cut from a frozen river, which are cemented together by water from a hose freezing in the joints. At dusk, the glasslike sculptures come to life when illuminated from within by colored lights.

China is by no means unique in producing ice sculptures; they can also be seen in Finland, on Hokkaido in Japan, and in Quebec City.

Snow

The moment snow begins to fall on the landscape, we instinctively rush for our cameras; yet capturing snowflakes as they fall can be tricky. The best time is when the flakes are large and they are falling against a backdrop of somber conifers before the branches become laden with snow. A slow shutter speed will exaggerate the size of the flakes as elongated streaks. But if the snow is falling fast and furiously, the flakes will be difficult to distinguish as white against white.

Great Wall ice sculpture internally lit in Zhaoling Park, Harbin, China, January at night. *Nikon F4, 80–200mm f/4 lens, Ektachrome 100S.*

Awesome ice sculptures glowing from colored lights within attract many tourists to Harbin around the time of the Chinese New Year. I tried both automatic matrix and manual spot-metering, and providing I spot-metered off a darker color, I found the exposures were very similar. With ISO 100 film, I needed to use 1-second exposures to stop down the lens several stops.

A light snowfall etches bare branches of deciduous trees so they stand out from dark conifers in a mixed forest. Within Wolong, China's largest panda reserve, snow is a feature of the winter landscape, although at lower elevations, it rapidly melts once the sun breaks through.

Taking photographs at ground level from within a forest at any time of year is difficult, and often disappointing, because without a

Mixed woodland, Wolong Natural Reserve, Sichuan Province, China, February. *Hasselblad 501 CM 150mm f/4 Sonnar lens, Ektachrome 100S.*

I visited Wolong, the largest giant panda reserve, in winter to photograph pandas in snow. Even though snow fell most nights, it invariably quickly melted at the lower elevations. This deciduous tree stood out from neighboring conifers because the branching pattern was defined by a light snowfall. For me, this is what makes the picture. Any more snow and it would have not had the same appeal.

large clearing, the only uncluttered viewpoint will be skyward. A river winding up through a forest provides a natural canopy break, whereas a man-made road needs time for scars on the landscape to heal; either will often provide a clear view of a portion of a snow-clad forest, particularly if there is a viewpoint where you can shoot across from one side of a valley to the other.

A heavy snowfall not only transforms irregular, jagged boulders into curvaceous lines but also obliterates eyesores in the landscape. Snow scenes always look so photogenic, but using an ultra-wide-angle lens is not necessarily the best option. Unless there is some interest in the foreground, a broad, white expanse is unlikely to arrest the eye. When arriving at a pristine wilderness area, ponder carefully the best place to set up a tripod, since you do not want footprints impinging into the frame, and they cannot be erased until the next snowfall.

Traveling for any distance in deep snow is quite impossible without wearing skis or snowshoes, which can be rented at ski resorts. If the ground is fairly flat, a handy way of transporting a camera bag and tripod is to lash them onto a child's plastic sled using bungee cords. Alternatively, you can use a large trash bag or old fertilizer bag as a snow sheet on which to place your photo rucksack. Three small pieces of cardboard—or better still, the plastic sheeting used to protect photographs in the mail—placed beneath each tripod leg will help spread the weight and prevent the tripod from sinking into snow.

Metering Snow and Ice

Frost and snow-covered landscapes, as well as close-ups, reflect more light than an average tone, so a straight reflected in-camera reading will cause white areas to appear as underexposed gray patches.

When taking a scene festooned with frost or blanketed by snow, it is difficult to find an

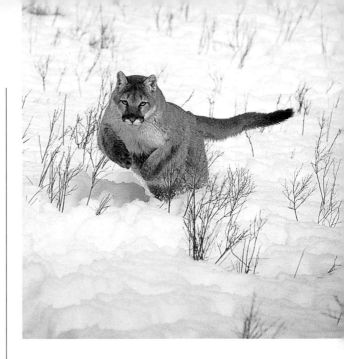

Cougar *(Felis concolor)* leaping through snow, Montana, February. *Nikon F4, 300mm f/4 lens, Fujichrome 100 (C).*

Most large animals that spend much of the year in a snow-free landscape contrast well against snow-covered ground, and the cougar is no exception. From a series taken with continuous motor drive, this was the only frame when the cougar made eye contact with the camera's lens at the same time both front paws were raised above the ground.

average-toned object from which to meter. You have several options: Use a separate hand-held light meter to measure the incident light falling on the white ground, use a Kodak gray card to meter the reflected light (be careful not to spoil the shot by walking into it and creating footprints), fit a homemade diffuser over the camera lens so it can be used as an incident light meter, or meter the snow or frost with the camera in a manual mode and open up one and a half to two stops on the reflected light reading. Adjusting the exposure compensation dial to +1 (or +2, if the entire frame is evenly lit with snow) is also an option, but you must remember to reset it back to 0.

Water Vapor

Compared with liquid water or solid ice and snow, mist is the least popular photographic subject of water's three states. This is perhaps not surprising, since mist and fog appear sporadically and then may not last for long. Nonetheless, mist adds wonderful atmosphere to a picture, and many a landscape is enhanced by a striking cloud formation.

Mist

Photographing through a veil of mist not only adds an ethereal quality to any picture but also helps blot out unsightly eyesores. By creating pale tones and pastel colors, it produces what are known as "high-key" pictures, in contrast to the somber shadows of a "low-key" scene.

Anyone who frequents wetland habitats, particularly in temperate regions during autumn, when mist can become a regular feature of the weather pattern, will have seen the small, misty pockets that appear above rivers and ponds or in damp hollows. In coastal regions and out at sea, extensive misty areas can develop.

Mist forms at the earth's surface as a very low cloud when warm, moist air passes over cold ground or is cooled at night so that the moisture condenses into minute water particles. Fog is simply dense mist. The ephemeral qualities of mist, which usu-

ally develops in the evening, become all too apparent once the sun warms up the air the next morning; a misty scene will fade before your eyes as the water vapor begins to evaporate. When misty conditions coincide with subzero temperatures, spectacular frosty conditions develop (see page 2).

In places with clean air and clear skies above, mist will be short-lived, so you have to work quickly before warmth from the sun's rays causes the water droplets to evaporate and the mist to disappear. An extensive misty area functions like a big diffuser, softening harsh, direct sunlight and shadows, or even wiping out shadows altogether.

Mist can make foreground objects, such as trees beside water or within a forest, as well as wildlife in water, more significant in a photograph, as the background becomes

Right: Red deer *(Cervus elaphus)* stag calling to his harem of hinds during the rut, Bradgate Park, Leicestershire, UK, October. *Nikon F3, 300mm f/4 lens with 1.4 teleconverter, Kodachrome 64.*

Mist has enhanced this early-morning ritual by separating the deer from the oak trees behind. Once the sun burned through the mist, the atmosphere was lost and the stag stopped calling. The starling perched on the back of one of the hinds was a bonus.

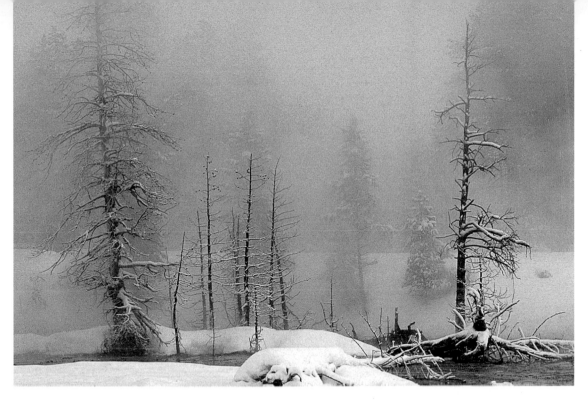

Above: Ghostly trees loom out of steam at Fountain Pots, Yellowstone National Park, January. *Nikon F4, 80–200mm f/2.8 lens, Kodachrome 200.*

Dead trees killed by an active thermal area look even more sinister when shrouded by steam. As I was photographing, the steam was constantly wafting in and out of the trees, so that no two frames were identical. This has to be an early-morning shot, taken before the steam evaporates in the sun.

Sun beaming through mist on frost-encrusted cottonwoods *(Populus deltoides),* Klamath National Wildlife Refuge, California, January. *Nikon F4, 35–70mm f/2.8 lens, Ektachrome 100 Plus.*
 Having earmarked these trees late one afternoon, I made a point of listening to the weather forecast that evening. When clear skies with a heavy frost were forecast, I left my motel while it was still dark and arrived at the cottonwoods before the sun appeared. Once the sun beamed through the low-lying mist, the frost began to fall from the branches.

indistinct and fades away into a misty haze. In addition to adding atmosphere to a photo, mist can be used to isolate foreground subjects, such as trees beside a river or whales in the sea, from their background.

As wilderness areas become opened up, evidence of human encroachment can be seen in the form of roads and electrical wires cutting across the landscape. Mist can be an easy (and inexpensive) alternative to blotting out such unsightly backgrounds and eyesores by digital means, if they cannot be eliminated simply by changing the camera angle.

. When photographing in thick mist, the minimum camera-to-subject distance should be used so as to get a well-defined foreground subject. Therefore, under these conditions, a wide-angle lens is preferable to a long telephoto lens.

Early morning is a better time to take misty scenes than at the end of the day, as the light level is constantly improving. When a rising (or setting) sun filters through mist, the sharply defined circumference is lost, and the soft edges blend into a golden sky. When a low-angled sun beams into mist, it can create a glowing aurora, as if lit by an

orange spotlight. In dull light, a misty haze may appear blue. This can be attractive, but a warming filter can be used to help counteract the cold feeling.

Metering mist can be tricky, because the pale tones are much brighter than average; if they cover much of the frame, they will register a high in-camera reading, resulting in underexposure. Unless the composition includes a dark patch equivalent in area to the pale mist, ignore the matrix reading. Instead, look for a gray tone, such as a tree trunk or a hillside, in the scene for spot-metering with the camera. Failing that, open up on the matrix reading; if you are uncertain by how much, it would be wise to bracket the exposures by gradually opening up in half- or one-third-stop increments.

There are various ways and means of generating atmosphere to a scene lacking mist. One is to attach a fog or mist filter in front of the camera lens. Several manufacturers produce a graduated fog or mist filter in different densities. Lee Filters also produces a mist stripe and an overall mist with a clear central spot. The stripe can be used to create an impression of a fog layer above water, whereas inversion of a mist grad will produce a misty foreground. A cheap alternative for an overall mist effect is simply to breathe on the prime lens, but you then have to work fast before the "mist" rapidly fades away in a warm atmosphere. Ironically, it takes about fifteen minutes for a fogged-up lens caused by bringing a cold camera into a hot, humid environment to clear. When a film director requires a misty atmosphere for a wide shot on a sunny day, a smoke machine comes to the rescue.

Siberian or amur tiger *(Panthera tigris altaica)* near Harbin, China, January. *Nikon F4, 300mm f/4 lens, Ektachrome 100S (C).*

I was working in subzero temperatures in a large enclosure where these rare tigers are bred. As one tiger walked out over a frozen lake, his warm breath momentarily became spotlit by the setting sun, giving him the appearance of a fire eater.

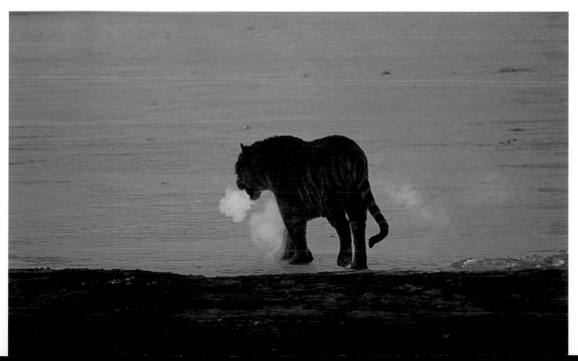

Rainbows

The formation of a rainbow will be evident only when several factors coincide. Most crucially, the sun needs to shine onto water droplets measuring 0.01 to 4 millimeters in diameter. These can be raindrops or the fine spray generated by a waterfall, fountain, or garden hose. Each water droplet functions like a prism by refracting and reflecting white light into the spectral colors. From the ground, a rainbow appears as an arching bow, but from an airplane or a high mountain, it is seen to complete a full circle.

Rainbows can be seen only when the sun beams onto water droplets from behind the viewer. Thus, in the Northern Hemisphere, rainbows will appear in the west during the morning and in the east during the evening. Within the main or primary bow, the spectral colors are arranged with red at the top and violet at the bottom. If a secondary bow forms outside the primary one, the colors are paler and reversed.

The colors are especially vibrant during a tropical storm, because the intensity increases with the size of the drops. A polarizing filter helps enhance the spectral colors, but since there is only one filter position where this works, you must view the effect through the camera. A slight rotation to

Rainbow over Gullfoss, or "Golden Falls," on Hvitá River, Iceland, July. *Nikon F4, 80–200mm f/2.8 lens, Ektachrome 100S with polarizing filter.*

We had intentionally delayed our arrival at Gullfoss, Iceland's most visited waterfall, so as to avoid the crowds. As we approached in early evening, I saw a rainbow dancing in the spray rising above the canyon rim. Using a polarizing filter helped enrich the spectral colors that formed an arc linking the twin cascades. Half an hour after we arrived, the sun began to sink behind a hill, and the magical scene faded before our eyes.

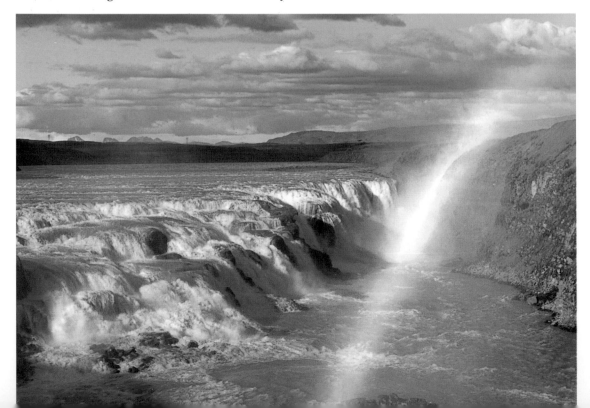

Clouds over Greenland, July. *Nikon F4, 20–35mm f/2.8D lens, Kodachrome 25 with polarizing filter.*

It pays to keep an eye on the sky. After hours spent crouching low over alpine plants, I stood to pack up my gear and noticed the dramatic rim-lit billowing cumulus backed by streaks of stratus clouds. I decided against cropping the horizon out altogether, because I needed a solid base to the frame as a contrast to the white clouds, so I positioned it low in the frame. A polarizing filter increased the contrast by darkening the blue sky

either side of this position will cause the rainbow to disappear from the field of view.

As the sun moves through the sky, so its angle to the spray changes, and thus the position of a rainbow varies not only with the time of day but also seasonally.

Moonbows

Few people have been lucky enough to see—let alone photograph—a moonbow. This occurs when light from a full moon is refracted and reflected within water drops. Even then, achieving a good shot is not easy. Focusing the camera in low light is always tricky, and even using a fast film, such as MS 100/1000 Fujichrome rated at ISO 800 or even 1000, a long exposure of several minutes will be needed, with the lens set on a wide aperture. A moonbow will appear white tinged with red.

If you have not uprated the ISO dial on the camera during daylight hours, you will need a flashlight to work at dusk. The world's slimmest flashlight is the 6-volt Hiplight (Flashcard in UK), which measures $3^1/2$ by $2^3/4$ inches (90 by 69 millimeters) and is a mere 4 millimeters thick, slipping easily into a photopack or vest. What is more, it is also water resistant.

Clouds

Clouds can make or break a picture. A sky blanketed with a complete cover of colorless clouds adds little to a landscape and is

Altostratus clouds lit by dawn glow, Alboran Sea, January. *Nikon F3, 70–300mm f/4.5–5.6 lens, Kodachrome 200.*

This glorious glow on a high cloud layer just inside the Straits of Gibraltar was short-lived. Working from a boat made a tripod impractical, so a medium-speed film was essential for this hand-held shot.

best excluded from the frame. On the other hand, a striking cloud formation backed by a blue sky or painted with a dawn or dusk glow can be riveting enough to be featured as a cloudscape, with merely a slither of horizon included at the bottom of the frame, or maybe all trace of land or sea cropped out altogether.

Clouds are formed in two distinct ways: Fluffy cumulus clouds develop as moist air rises and condenses into water vapor, and sheetlike stratus clouds form when an air layer is cooled. For most of the time, when working on the ground, pictures will be composed looking up to the clouds; from a

plane, the viewpoint is reversed, so that you look down on them. Mountaineers have the best of both worlds: When the clouds are high, pictures can show peaks with clouds in the sky, whereas a climb up through low-lying fog may be rewarded by a clear vista of a peak rising from a sea of cloud below.

Meteorologists have an extensive vocabulary to designate cloud types. Nimbus refers to a rain- or snow-bearing cloud. The typical dark rain clouds with an obvious rain curtain extending to the ground are known as nimbostratus. Anvil-shaped thunder clouds, or cumulonimbus, can result in some dramatic contrasty lighting. "Mares'

tails" is the colloquial name for thin, wispy-edged, sometimes featherlike cirrus clouds. These are formed entirely from ice crystals at a high elevation of 3 miles or more, where the temperature never rises above freezing.

Apart from noting a weather forecast, cloud pictures cannot be planned; they are simply a matter of reacting spontaneously. Sometimes it may be light on the clouds that attracts: rimlighting from behind or an ephemeral pink, rose, or orange glow. Even black, menacing clouds can make a picture, especially if there are gaps between them that allow objects on the horizon to be

Geyser erupting inside Alcedo Crater on Isla Isabela, Galápagos, March. *Hasselblad 500 C/M, 80mm f/2.8 Planar lens, Ektachrome Professional.*

Some years ago, I had special permission to camp inside Alcedo Crater, a caldera on Isabela. Close to the crater rim is a geyser, which I photographed as the sun peeped above the rim, grazing the light across the crater floor. The areas still in shadow make a perfect foil for the white gas plume.

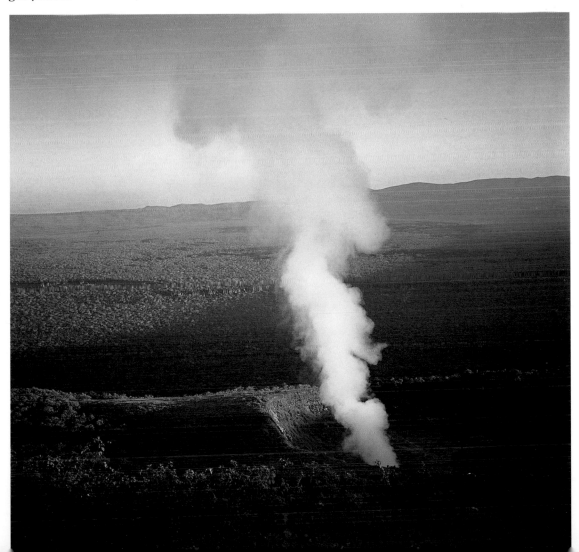

silhouetted beneath. Other interesting pictures may be created by the juxtaposition of ever-changing shapes, such as ethereal wisps snaking around a peak or mares' tails radiating out from the horizon. Occasionally, distinctive anthropomorphic shapes develop. I shall forever regret being unable to pull off a road in Iceland in time to photograph a cloud that looked for all the world like a realistic predatory bird.

It is ironic that when composing cloudscapes, the perfect composition appears to dissipate all too quickly, yet when you want to photograph a subject bathed in direct sunlight, it is very much a waiting game, as the clouds tantalizingly persist in covering the sun!

To achieve cloudscapes with rich colors—blue skies or glowing dawn and dusk shades—err on the side of underexposure. Never look at the sun through a camera with a long lens; it may damage your eyes. For increased contrast between a blue sky and white clouds, try to shoot with the sun on your left or right so that you can gain the maximum effect with a polarizing filter.

Strokkur geyser bubble immediately prior to eruption, Geysir, Iceland, July. *Nikon F4S with high-speed battery pack, 80–200mm f/2.8 lens, Provia Fujichrome rated at ISO 800.*

One of many objectives I had on a trip to Iceland to take pictures for this book was to capture the moment the Strokkur geyser comes into view as a gigantic blue bubble, with the steam bubbling beneath. By using Provia Fujichrome rated at ISO 800, I could use a shutter speed of 1/1000 second. After prefocusing the camera on a tripod, I locked up the mirror. By keeping both eyes on the geyser vent, I could anticipate the moment to begin the sequence, which I recorded at a rate of 5.7 frames per second. Even so, only one frame in each eruption showed the convex bubble with the steam below the meniscus just before the surface burst.

Geysers and Fumaroles

Hot springs occur in many parts of the world; geysers associated with active thermal regions are not nearly so widespread. The prime sites are Yellowstone National Park, which has around four hundred geysers in total (some two-thirds of all geysers), as well as Iceland, New Zealand, Et Tatio in Chile, and the Kamchatka Peninsula in Russia's Far East.

As subterranean superheated water accumulates, steam begins to form until it boils up, culminating in an eruption that, depending on the geyser, may last for a minute or two or persist for up to an hour.

The interval between eruptions also varies from one geyser to another. Even two neighboring geysers at Geysir in Iceland show quite divergent patterns: Strokkur has a mere ten- to fifteen-minute interval between eruptions, whereas Geysir itself erupts only after an earthquake. The worldwide term *geyser* comes from the Icelandic *geysir,* meaning "spouter."

The easiest geysers to photograph are those that erupt at regular and frequent intervals. A white sky is the worst possible backdrop for a white geyser jet and steam cloud. A blue sky or dark storm clouds provide a good contrast, as does a dark hillside. The short-lived glowing sky at dawn or dusk all too rarely coincides with the eruption of a geyser.

The least arduous way of photographing an eruption is to use a tripod, since bracing your arms to hand-hold a camera in anticipation of an eruption is tiring to say the least. I always opt for a tripod so I can prefocus the camera on the fixed point of the geyser vent.

Before composing the shot, you need to watch which way the steam column moves or check out the wind direction to achieve a good framing. Choose a lens that allows plenty of space into which the plume can extend. I have found a 20–35mm zoom ideal

Fumarole vent with sulfur crystals, Alcedo Crater, Isabela, Galápagos, March. *Nikon F3, 105mm f/3.5 Micro-Nikkor lens, Kodachrome 25.*

Attractive yellow sulfur crystals may arise around the vents of some fumaroles that emit sulfurous gases. Such fumaroles are known as solfataras.

when working many geysers at close range. An erupting geyser provides a fun photo sequence, although you will need plenty of film in the camera. A few people in the

frame will provide useful scale against a big geyser plume.

Unlike fumarole photography, warmer weather is preferable when photographing geysers, since it reduces the amount of steam, which can obscure the bubble and hence spoil the picture.

Fumaroles are steam vents where hot springs emit volatile gases. They occur within craters and calderas of active volcanoes, within lava flows, and even in lava lakes. The gases emitted from a fumarole vary from one vent to another, although steam and carbon dioxide are the most widespread. Fumaroles that emit carbon dioxide in sheltered depressions where little or no wind blows away the gas can prove lethal to animals, if the gas accumulates as a dense layer at ground level. Death Gulch in Yellowstone National Park is one such locale, where even brown bears have succumbed.

Polar bears *(Ursus maritimus)*, Cape Churchill, Manitoba, Canada, November. *Nikon F4, 300mm f/4 lens, Kodachrome 200.*

We all know what happens when we exhale in cold air. If you look at the bear to the right of the picture, there is no way of hiding from where it has lost some surplus gas! Whenever I lecture about life in polar regions to schoolchildren, this picture always brings a laugh. I used the flank of the left bear as a gray card and spot-metered off the fur.

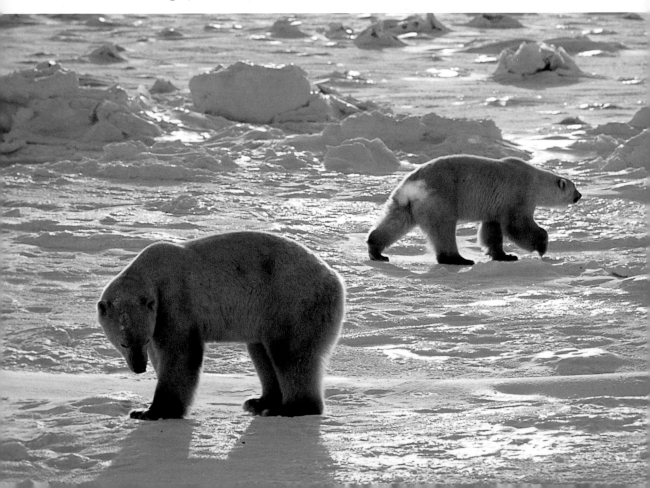

Bubble in mud pool at Whakarewarewa, New Zealand, January. Nikon F3, 180mm f/2.8 lens, Kodachrome 64.

As there is no regular interval between the production of mud bubbles, you have to be constantly on the alert. Even so, you have to be prepared for some failures because the shutter is released either too early or too late. The gaps in this bubble show it was captured only milliseconds before it burst.

In the same way that our own breath shows up clearly on a winter's morning, so fumarole gases are most conspicuous in colder air. Thus winter days or early mornings in summer are good times to photograph fumaroles. Once the sun rises and warms up the air, fumaroles are invariably unimpressive. Cold temperatures or backlighting also can help capture the warm, moist breath of a spouting whale or the moment a terrestrial mammal exhales.

Mud pots are a feature of some geyser basins. They form as a result of sulfuric acid (produced from hydrogen sulfide gas, which smells of rotten eggs, reacting with water and the action of sulfur bacteria) breaking down rocks into wet clay. A mud pool gurgles and bubbles from the action of the fumarole beneath it. Capturing a mud bubble when it is fully expanded just before it bursts requires considerable perseverance and quite a lot of film.

Water and Wildlife

Working as a marine biologist was what inspired me to take up photography. For several years, I confined my photography to the marine world, but gradually I broadened my horizons to include any kind of wildlife as well as plants.

Where Land and Water Meet

The majority of animals that live permanently in water are either inaccessible or too small for outdoor photography. With the exception of whales and dolphins—and even these may require a miniexpedition to reach them—the animals most accessible for photography are those living at the interface of land and water, migrating from one to the other.

Here there are opportunities for taking wetland scenes with a mobile element. There is arguably no place more evocative than the Okavango Delta in Botswana. This, the largest inland delta in the world, is a vast oasis in the desert. Here the boundaries between land and water are forever changing, as islands enlarge and shrink in response to rising and falling levels of seasonal swamps. Groups of red lechwe, a kind of antelope, with their deeply splayed hooves, move with grace and agility through the swamp water, sending up white fountains in their wake.

Wetlands and coastal regions that attract large numbers of birds during the winter months are a wildlife photographer's dream.

Even a single day at such a location is unlikely to disappoint, and if a visit coincides with a colorful dawn or dusk, it can, indeed, be an awesome experience. Some reserves provide permanent blinds for photography; others can be worked using a vehicle as a mobile blind.

The photo opportunities along the auto-tour route at Bosque del Apache National Wildlife Refuge in New Mexico can be spectacular. Twelve thousand greater sandhill cranes (two-thirds of the world population) plus some sixty thousand snow geese are attracted here each winter. With a colorful dawn or dusk sky, the water or ice becomes briefly tinted with pink or orange tones.

Another winter avian spectacle occurs in Britain on the Ouse Washes in Cambridge-

Right: Sandhill cranes *(Grus canadensis)* silhouetted at dawn on roosting pond at Bosque del Apache Refuge, New Mexico, December. *Nikon F4, 400mm f/4 lens, Ektachrome 100S.*

Making a decision where to set up a camera for dawn or dusk shots of wildfowl gathering at their roost sites is always something of a lottery. But after several days in one location, you can begin to predict the most likely spots based on your own observations and tapping into local knowledge.

Above: Red lechwe *(Kobus leche leche)* leaping through a floodplain, Botswana, September
Nikon F4, 300mm f/4 lens, Ektachrome 100S.

*Lechwe are well adapted to life in their semiaquatic terrain of floodplains and swamps. On
my first trip to Botswana, I was eager to capture the way they move through water, sending up a
white spray in their wake. This was virtually a grab shot, as we suddenly came upon the lechwe
racing away through the water. Fortunately, the light had not changed since I last metered it, so
I could go with the previous exposure.*

Manchurian cranes *(Grus japonensis)* dancing on snow, Hokkaido, Japan, February. *Nikon F4, 500mm f/4 lens, Kodachrome 200.*

Although the sun was shining when I took this picture, the temperature was well below freezing, so I was glad of the chemical hand warmers inside my gloves. The sidelighting has helped separate the white birds from the snow. Once persecuted, the cranes are now protected and populations are gradually increasing.

shire (see page 80), where thousands of wild ducks and swans are attracted to flooded meadows. In severe winters when the water freezes, the swans use the frozen water as an icy runway to generate enough speed for liftoff. On the north coast of Hokkaido in Japan, whooper swans congregate in sheltered bays where, in severe winters, the sea freezes over. Also on Hokkaido, Manchurian cranes gather on snow-covered fields, where they perform their balletic courtship displays in freezing conditions.

As a jumbo jet requires a long runway for takeoff, so swans need a good stretch of water or ice for their pattering takeoff runs.

Even by using an autofocus system, achieving a sharp image of a moving animal is by no means guaranteed. Unless the active focusing sensor is held on the subject and the focus is maintained by keeping the shutter release button partially depressed, the shot will be lost as the AF system "hunts." To ensure that one or both eyes of the animal are in focus, the AF sensor needs

to be positioned adjacent to the eye, not on the wing or the body. With a manual lens, it is possible to take at least one frame by pre-focusing the camera and releasing the shutter as the bird's head comes into focus.

If you want to freeze all motion, use the fastest shutter speed possible (1/500 or preferably 1/1000 of a second) by shooting with the lens wide open. For a creative interpretation of a group of birds lifting off, select slow shutter speeds (1/30 to 1/2 of a second).

As water freezes into ice, the margin between land and water becomes less distinct. In polar regions, as penguins, polar bears, and many seals move freely across the ice, they can be photographed against a uniform background. At any latitude, once ponds and lakes freeze over, they become large, open, flat areas with unrestricted views of animals. No longer are legs submerged in the water or bodies hidden behind shrubs or trees, as animals walk or interact with one another.

Unless you are prepared to spend a long period on a ship at sea, the best place to photograph seabirds is when they come ashore to nest. Then, as colonial birds such as gannets, kittiwakes, and murres come and go from their clifftop nest sites, they can be panned in flight against a sea backdrop.

Polar bears *(Ursus maritimus)* play-fighting on ice, Cape Churchill, Canada, November. *Nikon F4, 200–400mm f/4 lens, Kodachrome 200.*
Uniform ice provides a flat surface and an uninterrupted view of polar bears frolicking. Working from inside a tundra buggy, I was able to warm my hands up during periods of inactivity.

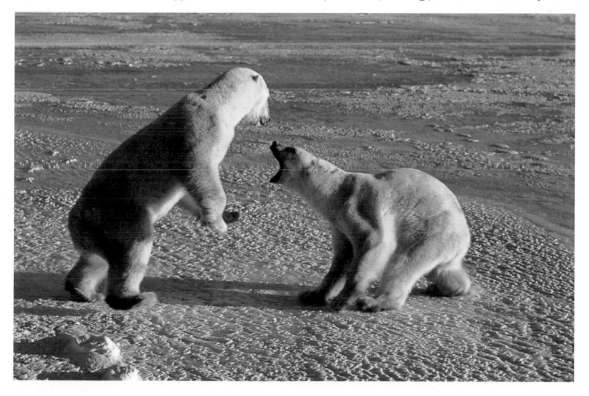

Living in Water

Completely aquatic animals, which spend their entire life in water, range in size from microscopic planktonic organisms to the largest animal alive today: the blue whale. All are superbly adapted to living and breeding in water. Most marine organisms spend their entire life in the sea. Similarly, most freshwater life remains in freshwater habitats. The salmon and eel are unusual fish in that they commute between fresh water and the sea.

Amphibious animals, notably frogs and toads, spend much of their lives on land but return to water to breed. Many waterfowl, notably swans and ducks, do the reverse. They need to feed in water, yet they nest on land.

Frogs or toads spawning in your own garden pond or waterfowl in a park or a reserve are good subjects to begin your wildlife and water photography. Repeated visits to the same location will pay dividends, as you gradually modify your techniques for gaining more satisfying pictures. You will get to know which time of day and which lens are ideal for a particular overlook or blind so that you will not need to carry every lens you own. Even so, popping a teleconverter into a pocket or gadget bag will extend the length of your longest lens for an unforeseen timid small bird. A 2X converter will increase the focal length of a 300mm lens to 600mm, but you will then lose two stops of light. The enforced slower speeds will not be too much of a problem with fairly static subjects. In poor light with active subjects, however, at least a medium-speed ISO 200 film will be needed, maybe even pushed one or two stops to ISO 400 or 800. Either way, a tripod is a must.

In addition to the host of waterfowl, lakes also attract wildlife such as beavers, muskrats, moose, or hippos. Once a beaver's dam or a bird's nest has been located, it is a fixed point to which the animals will repeatedly return. This makes photography much easier than attempting to track down animals constantly on the move through water. Mammals tend to have an acute sense of smell, so it is crucial to approach them upwind, with the wind blowing from them to you and not the other way around. Birds, on the other hand, cannot smell and will react only to visual stimuli. To avoid any chance of frightening birds into deserting their nests, use a long telephoto lens. Approach slowly, preferably reducing your profile by crouching or even crawling. If the bird leaves the nest and fails to return, retreat immediately and revise your tactics. Check to see if there are a couple of trees from which you can string a camouflage net and work behind the temporary screen.

On treeless terrain, you may need to work from a blind, although the presence of

Toad *(Bufo bufo)* with parrot's feather in a Surrey pond, UK, March. *Nikon F4, 200mm f/4 Micro-Nikkor lens, Ektachrome 100 Plus.*

This is a case where a polarizing filter is of little use, for it cannot penetrate through silty water. By ensuring that the beady eye was pin sharp and the depth of field small, the interest is automatically focused on the eye.

Red-throated loon, or diver *(Gavia stellata)*, on nest beside Loch of Fladdabister, Shetland, UK, July. *Hasselblad 500 C/M, 150mm f/4 Sonnar lens, Ektachrome 64.*

Before photographing this red-throated loon on its nest, I had to obtain a permit, then I had to erect a portable blind. Some hours later, after shooting several rolls of one bird on the nest and another swimming in water, I was unsure how to make my exit. I decided to collapse the blind on top of me and walk slowly backward. The loon barely blinked, quite unfazed by the curious spectacle of a retreating photographer. Rather than fill the frame with the bird, I opted for a lens that included the waterside location, which is so typical of the loon's nesting site.

a blind immediately pinpoints the whereabouts of the nest, which can be a disturbance in itself. In some countries, notably Britain, a license is required to photograph at or near the nests of rare birds. Before this is granted, the photographer must provide proof of his or her ability to photograph common nesting birds.

Hippos have a distinct diurnal movement between land and water: During the daytime, they wallow in water, surfacing briefly to breathe and to defecate. Once darkness falls, they emerge to feed on land. It is not difficult to take pictures of hippos wallowing in water by driving up to a hippo pool and spending a few minutes snapping away. However, getting a good action shot—of any animal—invariably involves spending a lot of downtime for maybe a few minutes of action. Hippos are no exception. Interesting behavior shots such as hippos yawning or fighting, as well as oxpeckers feeding on ectoparasites living on the skin, require the camera to be ready-loaded (preferably supported on a bean bag or a window mount) and approximately prefocused so that when the action begins, all that is required is for

the framing and focus to be checked and maybe fine-tuned.

When shooting animal portraits against the light and not opting for a silhouette, use a flash to reduce contrast and to put a highlight in an eye. If water appears in the frame, avoid using the flash-on-camera scenario, whether built-in or attached to the hot shoe, so that there will not be any risk of flash being reflected off the water surface back through the camera lens. You can mount the camera on a tripod and hand-hold the flash to one side, using a flash extension lead to connect it to the camera. Alternatively, mounting the camera and the flash onto a flash bracket will produce a much more flexible setup for keeping up with mobile subjects. When using flash as a fill, I meter the available light using the manual mode, stick with this, and dial in one and two-thirds stops on back of my Nikon SB26 flash unit.

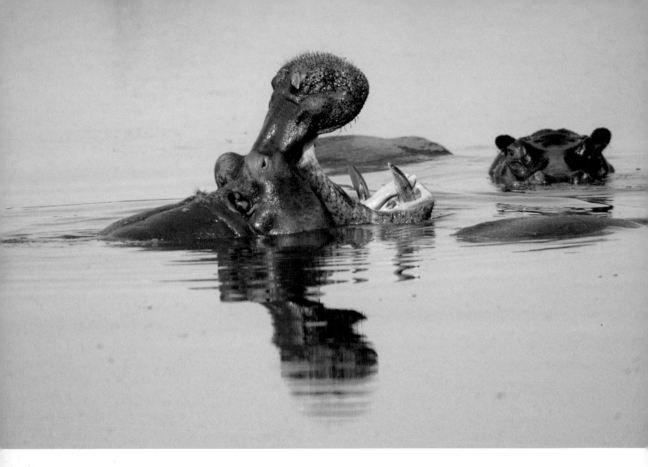

Hippopotamus *(Hippopotamus amphibius)* yawning in pool at Duma Tau, Botswana, September. *Nikon F4, 500mm f/4 lens, Ektachrome 100S.*
As hippos spend most of the day wallowing in water and usually emerge only at night to browse on land, it is safe to photograph from outside a vehicle. Even so, I needed a 500mm lens to get a shot of the mouth agape with a reflection, showing the hairy upper lip against the pale-toned water.

A motorized boat is essential for covering distance quickly when working large lakes or long stretches of rivers, but it is not conducive to getting close to wildlife, so make sure before you set off that the boatman understands your hand signals. It is preferable to cut the engine before reaching the best camera position so you can gently drift toward the subject.

A canoe or an inflatable, which can be paddled, punted, or rowed slowly through calmer water, will allow a closer approach to timid wildlife than a motorized boat and is an idyllic way of working a wetland habitat.

Even then, the camera needs to be at the ready to get at least a few frames before a bird takes off or an aquatic mammal submerges. Better still, a floating blind, made by constructing a framework above a boat over which camouflage material can be draped, provides an effective disguise, allowing opportunities for a close approach to the wariest of aquatic animals. A versatile tripod, such as a Benbo, which can be set low with the legs straddling even the narrowest of canoes, will free both hands.

Standing on the deck of a moving boat to photograph whales or dolphins leaping out

of the water requires a totally different approach from working on land or in a small boat on calm water. For a start, you cannot be sure where the animal will surface after a dive, which means some nifty footwork is needed as soon as you hear a blow. For this reason, a tripod is out; a shoulder stock or a rifle support will help steady a hand-held camera with a long lens. A 300mm lens is a good length for most shots, although it is useful to have a teleconverter in a pocket and a body with a shorter lens at hand. Manual focus gives me a higher success rate than autofocus for this kind of photography, because if the focus sensor moves off the whale or dolphin, you miss your shot.

Common dolphins *(Delphinus delphis)* leaping from Sea of Cortez, Baja California, Mexico, February. *Nikon F4, 300mm f/4 lens, Kodachrome 200.*
There is no shortcut to photographing wild and free dolphins; you have to be prepared to invest considerable time when working from a boat at sea. Fast eye and hand coordination is essential, as well as a fast motor drive and plenty of film.

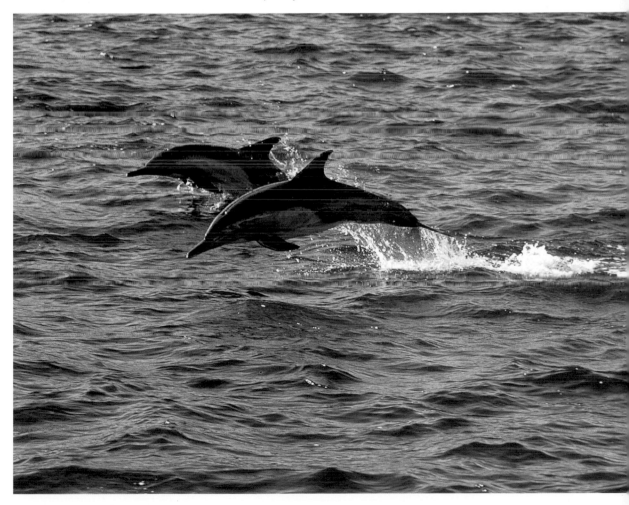

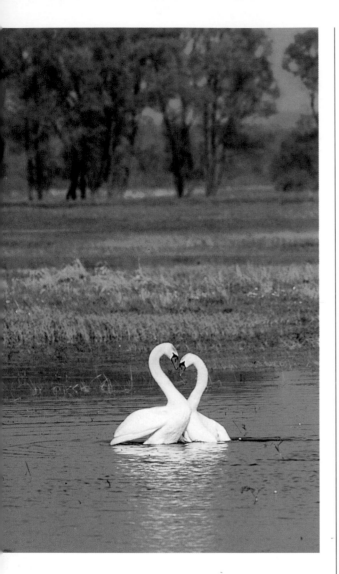

Mute swan *(Cygnus olor)* courtship,
Biebrzanski National Park, Poland, May.
Nikon F4, 500mm f/4 lens, Ektachrome 100S.
*This is the only time I have witnessed the
enchanting courtship display of mute swans.
Using a van as a mobile blind and a window
mount to support the camera, I watched as
the swans bent down to feed with their heads
moving in synchrony. Then they tossed and
swung their necks, ending with their bills
touching so that they completed an appropri-
ate heart-shaped design.*

Moving Through Water

For most of the year, the odds of pho-
tographing wild salmon are far too slim to
contemplate investing any time, but when
they migrate upriver to their spawning
grounds, they have to negotiate falls, and
here photographs can be taken of salmon
leaping clear of the water or navigating stony
rapids. Local people, especially salmon fish-
ermen, will know the narrow time slot when
a particular salmon run occurs. Salmon gen-
erally have favorite leaping places, so it pays
to watch for a while to determine where they
leap most frequently before attempting any
photography. Then look around for a natural
rock outcrop overlooking this part of the fall.
Popular locations, such as Brook Falls in
Alaska, may have raised platforms overlook-
ing the river for visitors to photograph
brown bears gorging on salmon, which can
also be used to take salmon leaping.

A side view of a swan coming in to land or
taking off presents opportunities for making
a photo sequence with continuous motor
drive by panning the camera in the same
direction as the swan is moving. Think
about viewpoints; a head-on shot of a swan
swimming has a great deal more impact if
the camera is down at the water level
instead of several feet above looking down.
On the other hand, a low camera angle is
quite unsuitable for depicting the geometric
pattern of the wake that forms behind
waterfowl and mammals, such as a water
vole, beaver, or muskrat, when they swim at
the water surface.

The elaborate displays involved with the
courtship behavior of some aquatic birds
make for more unusual action shots, as
well as exciting opportunities for a photo
sequence. For instance, a pair of great
crested grebes will dive in unison and
emerge, each carrying water plants in their
bills. They swim toward each other, rising
high up out of the water as their breasts
touch and their heads sway from side to side.

Penguins are flightless birds that may look rather clumsy as they hop from one rock to another on land, but once in water, they move with grace and speed. Just as fish swim as a shoal to confuse their predators, so penguins raft together on the sea surface and congregate when they dive underwater. On submerging, they use their flippers to "fly" through the water.

Feeding in Water

Portraying the varied feeding techniques of aquatic birds can be an absorbing ongoing project if you restrict yourself to wild birds. For nonpurists, photographing captive birds in wildfowl collections can help save time, although this is not nearly so challenging as working on location. To prevent captive birds from escaping, one wing has to be pin-

Heron with fish on beach, Ujungkulon National Park, Indonesia, July. *Nikon F4, 500mm f/4 lens, Ektachrome 100 Lumière.*

I noticed this heron walking along the surf line before wading out into the sea. For me, this frame is a more pleasing, harmonious composition, with the dark surf line and the tree shadows framing the sunlit beach, than shots of the heron in the water catching the fish.

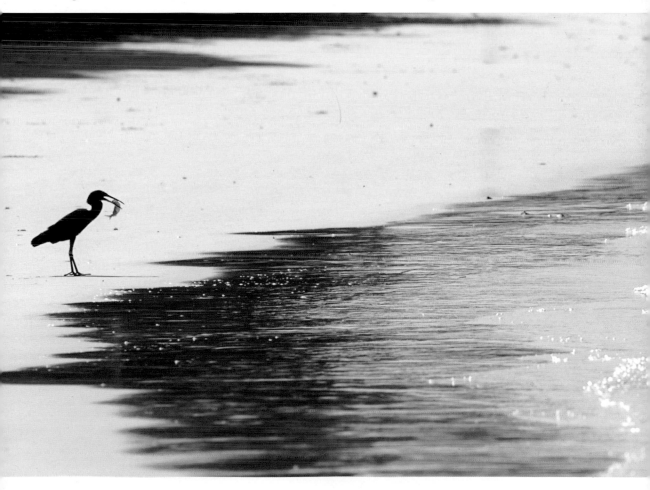

ioned by cutting the flight feathers. If this side is shown in a photo, it will invariably be detected by hawk-eyed birders, so it is not worth pretending a captive bird was stalked in the wild.

In shallow water, where edible plants break the surface, swans and ducks can feed merely by dabbling their bills and pulling at the vegetation. In deeper water, they have to upend to reach submerged aquatic plants. Wherever I find a drivable road that runs through a marsh or wetland area, I use a car as a mobile blind for taking pictures of birds feeding, whether it be mute swans on marsh plants in Poland or grey herons on fish in an Irish tidal lough. With the camera supported on a Kirk window mount, I am virtually ready to shoot, with only a fine adjustment to the composition and focus needed.

Arresting the motion of a kingfisher as it plummets toward the water after a fish requires either extremely fast reflexes and a fast film or, preferably, high-speed flash and a light beam trigger. On the other hand, all that is needed to get a kingfisher alighting on a post with its bounty is a keen eye and a camera with a long lens.

Capturing the moment when an osprey rises up from the water with a wriggling fish in its talons requires fast hand-eye coordination and a fast autofocus system. With a long telephoto lens (preferably at least 600mm), it is easier to photograph bald eagles gorging on the last salmon run of the year at Haines, Alaska.

One of the most predictable places to take vast numbers of birds feeding is in an estu-

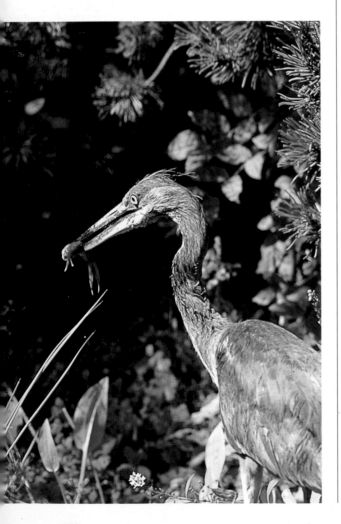

Grey heron *(Ardea cinerea)* fishing in garden pond, Surrey, UK, August. *Nikon F4, 500mm f/4 lens, Ektachrome 100S.*

When my husband visited our local pharmacy, he found a wild grey heron sitting on the sidewalk looking somewhat dazed. He picked it up and carried it more than a mile back to our garden pond, where it remained motionless, backed up against bushes. As dawn broke, it walked to the water's edge, eyeballing our resident goldfish. Using a terrace beside the house gave me an elevated vantage point for photography, and provided I made no sudden movements, the heron tolerated my presence. Most of my shots were simple portraits, until I saw the heron freeze before it lunged toward a free meal. As I took this picture, I had mixed emotions, glad the heron was recovering from its collision with a car, but sorry to see some of our goldfish disappearing so quickly.

Long-billed dowitcher *(Limnodromus scolopaceus)* feeding in Elkhorn Slough Reserve, California, November. *Nikon F4, 500mm f/4 lens, Kodachrome 200.*

With a few hours to spare before I caught a plane, I decided to visit a new reserve. I was rewarded as wading birds flew in to feed in shallow water. The concentric ripples appeared as the dowitcher's long bill entered the water.

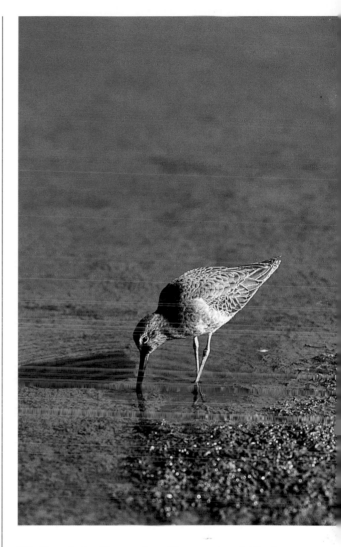

ary, where waders and some geese congregate in winter to feed on invertebrates or eel grass as the tide ebbs down the shore. Estuaries can be bleak places in winter, but hearing the haunting calls of massed waders and witnessing their sudden liftoff, followed by rapid wheeling and turning, is an unforgettable experience. Waders can feed only when the mudflats—home to their invertebrate food of worms and mollusks—become exposed. As the tide turns and begins to advance up the shore, it covers the flats, until ultimately the birds have no option but to lift off. It is then possible to fill the frame with waders; the only decision is whether to use a fast shutter speed to freeze all action or a slow one to blur it.

The easiest way to work waders is to check out the time of high water so you can arrive as the incoming tide pushes the birds up toward the last remnants of the exposed flats, where they can be photographed as they feed. In locations that are frequented by walkers, joggers, and horseback riders, I have approached waders without any cover simply by walking down to the foreshore. On the other hand, in remote areas with few visitors, the only way I could hope to get pictures of massed waders was by sitting in a blind waiting for the birds to be pushed up toward me by the rising tide.

Flamingos congregate in large flocks in shallow lakes to feed and breed. They have evolved an intriguing method of feeding.

Wading into the water, they extend their long necks so they can turn their bills upside down to strain out planktonic organisms through bristles (see page x). In calm water, the statuesque birds are replicated in mirror images, as indeed are any birds feeding in weed-free water.

All of the above examples are predictable ways to photograph birds feeding. In addition, there is also the possibility of a chance encounter, such as witnessing a feeding frenzy at sea when a shoal of fish approach the surface.

Birds are not the only animals to take advantage of these food bounties. In Alaska, I have seen sharks feeding on herring balls. Anyone fortunate enough to witness the communal feeding of humpback whales when they corral fish with a bubble curtain and rise with their gargantuan mouths agape is in for a treat.

Some animals are creatures of habit, so that once you have discovered a place and time where a muskrat or a water vole favors feeding, it will invariably be found there regular as clockwork munching on aquatic plants. It may be necessary to use a tree or a camouflage net as a screen, but these can be dispensed with in places where people habitually pass nearby.

Falls on rivers that salmon have to negotiate during their spawning migration are predictable places to photograph brown bears as they gorge on this seasonable bounty. Capturing a brown bear feeding on a salmon is very unlikely to be achieved as a chance encounter, however. Research into the best—and safest—locations to view bears feeding on a salmon run, as well

Lesser flamingos *(Phoenicopterus minor),* Lake Bogoria, Kenya, April. *Nikon F4, 200–400mm f/4 lens, Kodachrome 200.*
To get both the sun-baked mud nests in the foreground and the marching nuptial communal stomp in the distance in focus, I had to stop down the lens, so I was glad I had loaded up with a medium-speed film.

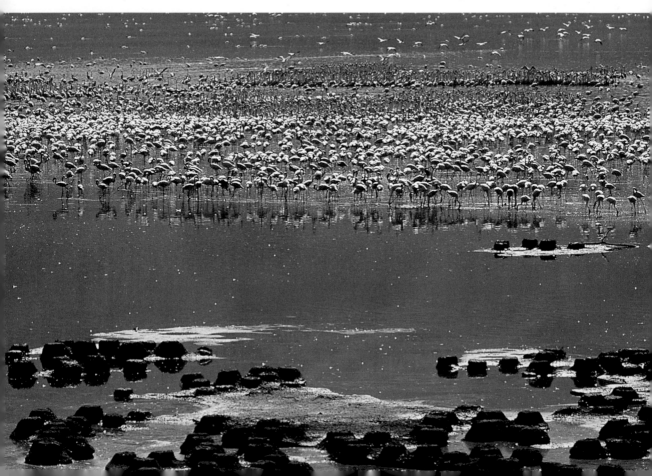

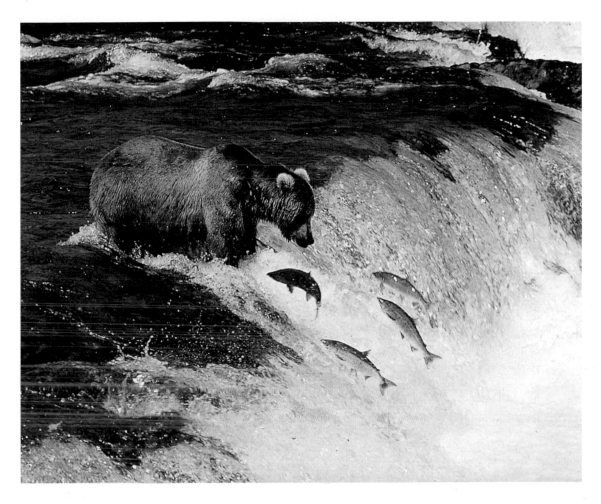

Brown bear *(Ursus arctos)* with salmon catch, Brook Falls, Katmai National Park, Alaska, August. *Nikon F4, 400mm f/4 lens, Kodachrome 200.*

During a salmon run, brown bears come regularly throughout the day to gorge themselves on the natural bounty. The bears fish in different ways: Some dive into the water; others stand above the falls waiting for fish to leap within reach of their outstretched jaws. This picture was taken from a secure platform overlooking the falls.

as the prime time of year, help to reduce the odds.

Considerable time and effort are required to get to many of the best wildlife locations. But if you have done your homework and are prepared to wait for optimum weather conditions—not necessarily clear skies with bright sun, as worthy pictures can be taken during a rainstorm—there is a good chance you will get your pictures.

Water Abstracts

Since the prime factor involved in taking abstract pictures is visualizing an aesthetic, as opposed to realistic, way of seeing images, it is difficult to write extensively about this aspect of photographing water. The crucial factor is having a seeing eye. No amount of reading will compensate for this; on the other hand, looking at abstract photographs and paintings will help you gain some insight about what works well. This section, therefore, has less text and concentrates on pictures with extended captions.

Abstracts exist at all magnifications, from stunning false-color images of earth from space to bizarre and beautiful photomicrographs taken down a microscope. In practical terms, however, the range of abstract subjects is limited by the choice of available lenses, spanning from telephotos to macros. There is no ideal lens for producing abstracts; I have used everything from a 500mm to a 70–180mm Micro-Nikkor (a macro zoom).

There are several distinct approaches to making abstract pictures (notice that I have deliberately written *making* rather than *taking*). My own preference is to search for abstracts among the natural world by means of selective cropping. Long telephoto lenses can be used to abstract parts of the landscape, such as a portion of a waterfall or an iceberg, the snaking surf line breaking on the shore viewed from overhead cliffs, sun and shadow areas on snow-covered hills, unusual cloud formations, a braided river crossing an outwash plain, or rivulets falling over a boulder in a stream. A macro lens, on the other hand, can be used to highlight a Lilliputian world that is so often ignored because it takes more than a passing glance to appreciate minutiae. Water drops trapped on hairy leaves, frost on a spider's web, or the random patterns of aquatic springtails that live on the water surface are quite exquisite when enlarged out of context from their more mundane surroundings.

We may not always be able to put the correct name to a particular fish or whale, but we can nonetheless recognize either one instantly from their shape, even a solid sil-

Right: Surf pattern on black sand beach, south Iceland, July. *Nikon F4, 500mm f/4 lens, Ektachrome 100S.*

As I stood on a headland looking at rafts of puffins in the sea, I became mesmerized by the ever-changing patterns as the surf crept up the beach and receded. The 500mm lens I was carrying for bird photography was perfect for achieving a tight crop of this fluid abstract. I loved the way the shapes and areas of black sand, white surf, and bluish wet patches varied with each wave.

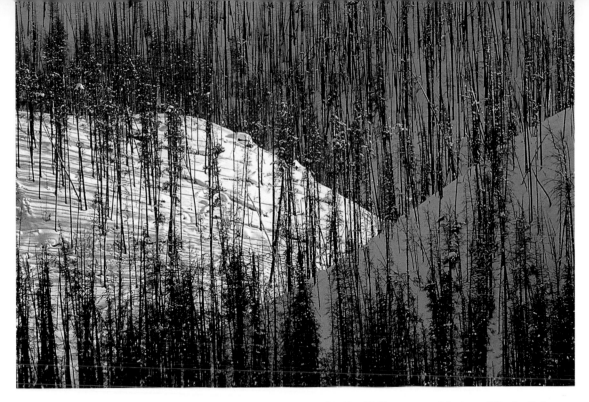

Above: Burnt lodgepole pine forest on snow-covered hills, Yellowstone National Park, February. *Nikon F4, 300mm f/4 lens, Ektachrome 100 Plus.*

 Killed by the 1988 fires that raged through Yellowstone, this stand of evergreen trees has lost many branches, revealing bare trunks with spaces between. The result: a study in lines and curves. Without the snow cover, the curvaceous lines of the hills would not be discernible through the dark trunks. Sidelighting late in the day helps outline the hill profiles.

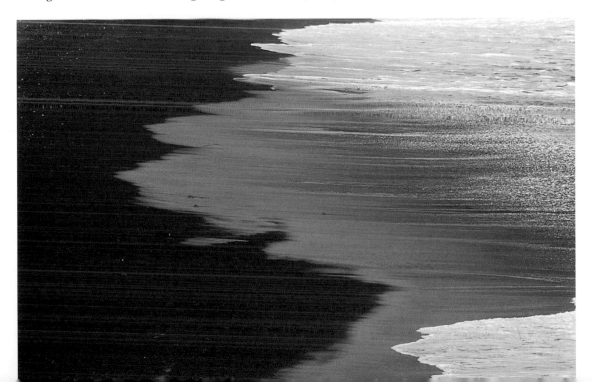

Frost patterns in mud beside Haines River, Alaska, November. *Nikon F4, 200mm f/4 Micro-Nikkor lens, Ektachrome 100 Lumière.*

Bald eagles are attracted to Haines in winter for a late salmon run. Depending on the weather and where the eagles happen to be fishing, some days are more productive than others. While my neighbors were bemoaning the lack of eagles, I was happily photographing frost patterns in the mud at the river's edge. The fallen leaf trapped in the ice adds a subtle contrasting color without detracting from the frost pattern.

houette lacking any hint of texture or color. But when we selectively crop a portion, such as scales of a fish, and isolate it out of context, the size of the subject is no longer apparent, so it develops an abstract quality.

To illustrate this approach, I have included a picture of colored algae, taken in an Icelandic stream. When the margins of the stream are included in the frame (see page 15), it is relatively easy to grasp the type of habitat, albeit an unfamiliar one. When, however, all hint of the margins is excluded and a polarizing filter is used to enhance the colors of the algae, it becomes difficult—if not impossible—to gauge the scale and hence recognize the subject.

Abstractions of the natural world also occur when surface ripples from wind, rain, a rising fish, or wakes created by birds or boats distort regular shapes of reflections from waterside trees or wildlife into ever-changing abstract interpretations. As the ripples die down, the abstract image begins to fade and the regular shape returns, so unless you can replicate the disturbance, such as by throwing a stone into the water, you have to work fast.

Wading out into the shallows of clear, coastal tropical waters can bring some rich rewards. Be sure to have on footwear as a protection against fish with poisonous spines, which are often camouflaged against

the bottom, or urchins. If a colorful tropical fish is photographed through a rippled surface, two mobile elements become introduced to the equation, so that the final effect becomes quite impossible to predict. These are inevitably grab pictures, and even then, there is an element of chance; you have no way of knowing whether you have taken a successful picture until after the film is processed. Also, no two images can ever be the same.

Abstracts can also be created in the camera. A slow shutter speed can be used to produce creative blurs of leaves moving down a stream or birds lifting off from water. Moving water can be captured as a milky blur by underexposing (by uprating the film) multiple exposures on a single frame. This works best when the tonal contrast between the water and the underlying rock is greatest.

A long exposure can also be used to create an abstract zoom burst by changing the focus during the exposure. You need to select an individual static—preferably colorful—subject such as a nesting bird or a clump of waterside flowers. Set up the cam-

Colored algae in stream, south Iceland, July. *Hasselblad 501 CM, 120mm Makro-Planar lens, Ektachrome 100S with polarizing filter.*

This is a fine example of how an unlikely subject can produce a wonderful abstract. A tiny stream filled with different colored algae snaking in the current kept me absorbed for several hours with different crops. A polarizing filter helped enrich the colors, which would make a wonderful design for a dress fabric. A wider view of the stream can be seen on page 15.

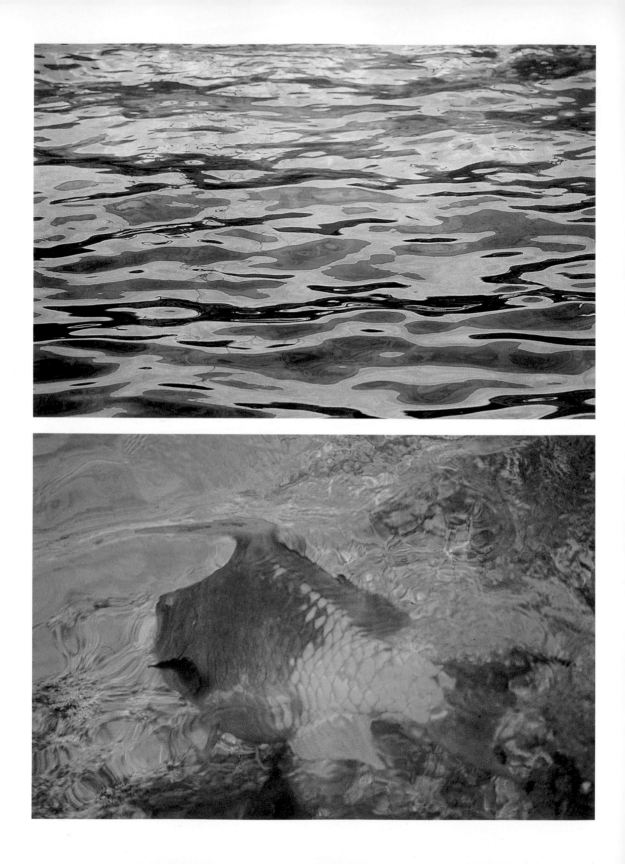

Above: Flowering water crowfoot ribbons streaking through river, Gwent, UK, June. *Nikon F4, 300mm f/4 lens, Ektachrome 100 Plus.*

Water crowfoot is a submerged, ribbonlike aquatic plant that produces emergent white flowers. These pastel-colored ribbons, together with the irregular dark water patches, convey an impression of a design created by a paintbrush. To get this picture, I leaned over a railing beside an elevated road next to the river.

Top left: Abstract water pattern, Windsor Safari Park, Berkshire, UK, January. *Nikon F4, 200mm f/4 lens, Kodachrome 200.*

As I sat waiting for a killer whale display to begin, I panned the camera across the pool and saw this exciting abstract reflection. I shot off a few frames and waited for the orcas. Over the years, the water abstracts have proved to be much more lucrative than the orca photos I took that day.

Bottom left: Through-water picture of parrot fish swimming in sea, Bermuda, April. *Nikkormat FTN, 135mm f/3.5 lens, Kodachrome II.*

When taking fish swimming beneath rippled water, there are two mobile elements that affect the ultimate image: the ripples and the moving fish. Inevitably, through-water photographs have to be grabbed on the spur of the moment and result in unpredictable pictures. As the fish swam past, I instinctively released the shutter, not having much faith that I would achieve a usable picture. Out of three frames, this was the sole one I kept. Even though the parrot fish has become abstracted, some characteristic features are nonetheless recognizable in this pastel-toned study.

117

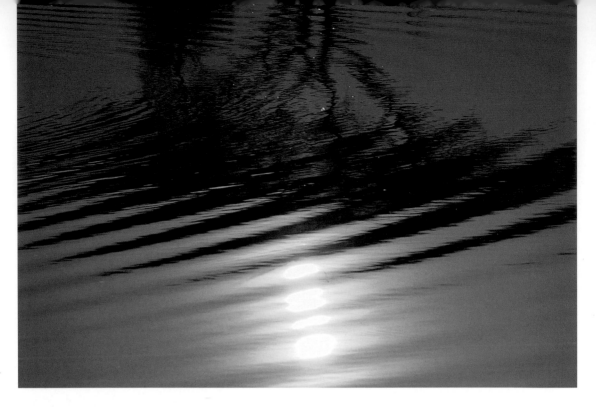

Distorted reflection of acacia tree *(Acacia tortilis)* silhouette in pool at sunrise, Duba Plains, Botswana, September. *Nikon F4, 300mm f/4 lens, Ektachrome 100S.*

We arrived at a shallow pool before sunrise so we could work out camera angles. After I had taken a more conventional shot of the complete tree and its reflection, the wind began to ripple the surface. It was then that I decided to crop in tight to create a simple abstract of the tree.

era with a zoom lens (an 80–200mm or 100–300mm will work well) on a tripod. Select a slow-speed film, and try to work on an overcast day, because you will need a shutter speed of at least $1/2$ second—preferably 1 second. If the light is bright, you can always reduce the exposure by using a neutral-density filter. A 4ND will cut out two whole stops. Focus on the subject with the zoom set at the longest focal length. Use a cable or electronic release to fire the shutter, and with the other hand, change the zoom setting to a shorter focal length. It pays to practice the zooming action before exposing any film. It is easier to produce an even zoom with a lens that has a simple trombone-type in-out movement than with one that has a focusing ring that has to be rotated around the lens barrel.

If abstracted images do not occur naturally and weather conditions are not suitable for inducing them, they can be created by using special-effect filters made by Cokin and Hoya. These include a clear glass filter smeared with colored Vaseline produced by Cokin filters, which tones and blurs the subject to convey an impressionist image; a rainbow spot filter that produces rainbow-colored streaks wherever highlights appear on water or wet surfaces; and dual-colored polarizing filters, such as red and blue or red and green, which produce some zany, unnatural colors. This last approach attracts me the least because it creates images that are a fabrication of reality. It can, however, be a fun way of shooting off the remains of a roll at the end of the day after more serious photography has been completed.

Close-ups

Water in all its states offers great potential for taking imaginative close-ups, whether they be of dew or raindrops, frost encrusted vegetation, icicles, or diminutive miniature aquatic plants.

Getting in Close

The simplest way to take a close-up is to attach a close-up lens to the front of a standard or short telephoto prime lens. Close-up lenses are available in different strengths. The larger the number, the greater the strength, thus a 2X lens magnifies more than a 1X.

The advantage of close-up lenses is that they are relatively cheap and can be slipped easily into a camera bag or a photo vest

pocket. But if you are at all serious about taking close-ups, sooner or later you should invest in a macro lens. They are available as prime lenses in several different focal lengths. Depending on the manufacturer, the shortest is around 50mm (some are 55mm or 60mm), followed by one at 90mm

Southern aeshna dragonfly (*Aeshna cyanea*) resting on water lily 'Attraction' in author's pond, Surrey, UK, August. *Hasselblad 501 CM, 120mm Makro-Planar f/4 lens, with 1.0 Proxar, Ektachrome 100S.*

When dragonflies are due to hatch from our garden ponds, I remove all yellow leaves and dead flowers from the water lilies so that I will have a better chance of getting an uncluttered shot if a dragonfly happens to alight on a flower. Because I needed a reasonable working distance, I selected a medium long lens with a close-up lens.

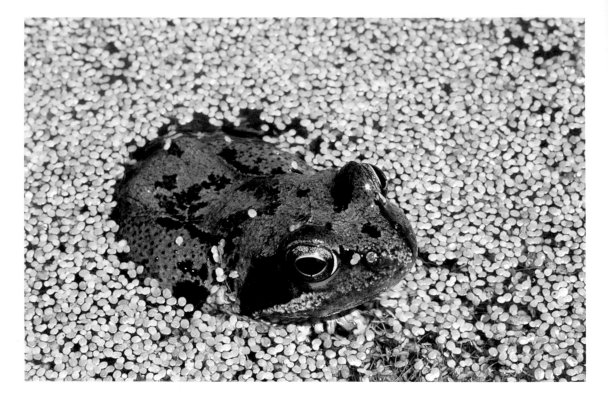

Frog *(Rana temporaria)* surfacing through duckweed *(Lemna minor),* Surrey, UK, June. *Nikon F4, 70–180mm Micro-Nikkor f/4.5–/5.6 lens, Ektachrome 100S.*
 One of the ponds in our garden becomes carpeted with tiny duckweed plantlets, and when I noticed a frog breaking the surface, I rushed for my camera and tripod. I chose a macro zoom lens to give me more flexibility with the framing the next time the frog surfaced. To gain a reasonable depth of field, I stopped the lens well down.

or 105mm, and the longest is 200mm. Nikon also offers the 70–180mm Micro-Nikkor macro zoom, which has a variable maximum aperture ranging from f/4.5 to f/5.6.

Which macro to buy depends on the price you are prepared to pay, which increases with the focal length, and the kinds of subjects you want to take. I have three prime macro lenses in addition to the Micro-Nikkor zoom. My favorite is the 105mm Micro-Nikkor. As it is a fast lens (f/2.8), it is easy to focus in poor light, and it gives me a life-size magnification and almost twice the working distance of a 60mm Micro-Nikkor.

A macro zoom enables precise cropping in tricky situations where it is difficult to physically move in closer. Imagine the following scenarios: You are crouching beside a pond to take a frog surfacing or frogs mating; you cannot move in any closer without the risk of falling in, but you want to crop tight from a vertical to a horizontal frame, so you simply zoom in. Alternatively, you are working on a rocky coast after the tide has turned, so you have to work quickly to prevent any risk of a wave swamping your gear. You set up the camera on a tripod to take a sea anemone in a rock pool. It doesn't

look too impressive, but there is no time to realign the tripod, so you quickly zoom in for a tighter crop.

Inserting extension tubes between a lens and the camera is another way of getting in close, but they are not the best option when standing in water or snow, as they can be fiddly to fit and there is always the risk of accidentally dropping them.

Depth of Field

Precise focusing is even more essential for taking close-up photographs than when taking landscapes, since the depth of field—the zone of sharp focus in front of and behind the plane on which the lens is focused—is much more limited.

With close-ups, the depth of field extends equally on both sides of the plane of focus as

Red maple *(Acer rubrum)* leaf in stream, Maine, October. *Nikon F3, 105mm f/3.5 lens, Kodachrome 200.*

In the autumn, where trees line watercourses, many leaves fall into the water and get carried downstream. Sometimes the journey is a rapid one, but obstacles often delay their passage. I was attracted by the simplicity of this image, with the red leaf adding a splash of color to the somber streambed. I needed a medium-speed film so I could use a fast shutter speed to freeze the movement, as the leaf was constantly buffeted against the stone by the flowing water.

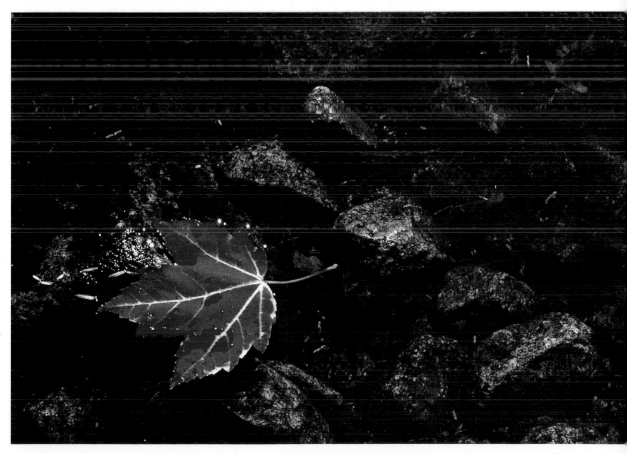

the lens is stopped down. Therefore, depth of field can be enhanced by focusing a short distance behind the front of the subject, which will be brought into focus by stopping down the lens. The ambient light level, the film speed, the maximum aperture of the lens, and not least, whether the subject is moving all influence the extent to which the lens can be stopped down. Subjects that lie along a single plane, such as a pond skater or a floating water fern, will not need the lens to be stopped down to the same extent as a three-dimensional water lily bloom.

Since depth of field is a function of image size and the aperture, it can be increased either by decreasing the image size or by using a slower shutter speed and stopping down the lens to a smaller aperture, such as from f/5.6 to f/11. Crisp close-ups will be achieved only by using a tripod, which also permits you to see the depth of field for a given magnification and lens aperture by manually stopping down the lens with the depth-of-field preview button. By using a tripod, sharply defined close-ups of three-dimensional, static subjects are possible even in poor light, because long exposures ($1/2$ to 1 second or more) can be used with a small aperture of f/11 or f/16.

Another factor to consider when selecting which aperture to use is whether you want the subject to stand out, or "pop," from the background. In this case, the depth of field has to be appraised very carefully. It needs to be sufficient for the subject to appear sharp yet not so much that the background begins to detract from the subject. Except when illustrating a plant's habitat—and then I opt for a wide-angle rather than a macro lens—my aim is to make the background as unobtrusive as possible in my close-ups. Once again, this is where the depth-of-field preview facility is so invaluable.

I have heard many people bemoan that they have abandoned using their depth-of-field preview because they cannot see any-

thing. To enable my eyes to adjust to the low light level, I open up the lens, put my eye up to the viewfinder, and slowly close down the lens, keeping the depth-of-field preview button depressed. If necessary, I repeatedly open up and close down the lens. It is then much easier for your eye to adjust to the low light through the viewfinder and so be able to appraise the extent of the depth of field.

Lighting for Close-ups

The way you light a close-up can make a world of difference to the final effect. For taking many aquatic close-ups, it is hard to improve on the available light. But there are times when a judicious helping hand can be an improvement. My most useful accessories for modifying naturally lit close-ups are a reflector and a diffuser.

Collapsible circular reflectors come in different sizes and finishes: silver, gold, and sunlite, or zebra. The last is a mix of silver and gold threads, which gives a more naturalistic light than either silver or gold on its own. Any reflector—even a piece of aluminum foil wrapped around some cardboard—can help to fill in shadow areas. The advantage of using a reflector over a flash to fill in is that you can see precisely the effect, whereas with a flash you can only imagine the end result. Made from white translucent material, a diffuser is held between the sun and the subject so that it functions like a minicloud and softens the harsh shadows produced by direct sunlight. When using a larger diffuser to soften an area around the subject, a reflector can be held beneath it to add a little additional light. Ready-made diffusers result in a loss of about two stops of light.

Flash is an invaluable tool for lighting close-ups, whether used as a fill for shadow areas or as a prime light source when working in locations with low ambient lighting, such as rock pools or caves, but care must be taken to avoid having reflections appear in water or on wet surfaces.

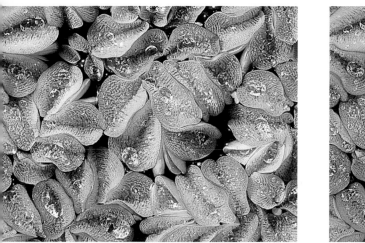 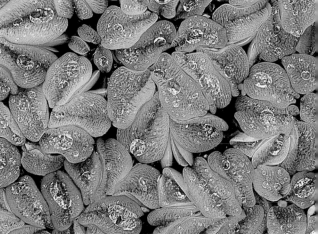

Floating water fern *(Salvinia auriculata)*, Surrey, UK, August. *Nikon F4, 105mm f/2.8 Micro-Nikkor lens, Ektachrome 100S.*
Left: In sunlight.
Right: With a diffuser.
This close-up was taken for a biology textbook after heavy rain, to illustrate how the conspicuous hairy coating on the plantlets buoys up water drops. Direct sunlight (left) casts a shadow on one side of the folded fronds; a diffuser, which cuts out two stops, evens out the lighting by eliminating the harsh shadows (right). I prefer the soft, indirect light because it is more restful to the eyes and adds some blue to the green. A similar effect can be gained by photographing when a cloud passes over the sun.

Dew and Raindrops

As dewdrops glisten in the sun, they transform any plant, including blades of grass. But only smaller drops randomly scattered over a leaf are true dew. A large drop at the tip of a grass blade or drops equidistantly positioned around a leaf margin have been excreted through pores by the plant itself. This process, known as guttation, is seen early in the morning after a warm, humid night. The secret to photographing such droplets, however caused, is to begin working at first light, before warming rays from the sun reach them. A belly crawl through the wet grass will reveal a worm's-eye view of a Lilliputian world.

If you want to stop down the lens to achieve a reasonable depth of field, use a small tripod; even a tabletop tripod may be adequate to support a camera with a macro lens. Alternatively, try shooting unencumbered by hand-holding a camera with a macro lens and shooting wide open. Using a shallow depth of field is not a lazy way to photograph close-ups. It is a different way. You still have to compose the picture, decide where to focus, and appraise the light.

Come autumn, when freshly fallen leaves carpet the ground, there are close-ups aplenty after rain has fallen. Rain enriches the color of leaves, and large raindrops function like magnifying glasses so that veins beneath the drops appear enlarged. To gain an overall sharp image of fallen leaves, mount the camera on a tripod so

123

that the film plane (the back of the camera) is parallel with the ground.

The best times to locate and photograph spiders' webs are after a rain shower or on misty autumn mornings, when they are bespangled with rain- or dewdrops that appear as myriads of sparkling gems. At these times, it always amazes me to see the abundance of webs on open ground. Webs come in a variety of shapes and sizes, each one requiring a different camera angle. Shoot funnel webs on the ground from above, and vertical orb webs from the side.

The air needs to be calm for photography so the webs do not vibrate, and the background should be simple and uncluttered. Once the sun rises, dew rapidly evaporates and the webs fade away into obscurity. Misty mornings will prolong the shooting time.

When larger water drops on vegetation are photographed at life-size or greater, they will function as miniature fish-eye lenses. If photographed with a conspicuous object, such as a colorful flower, behind them, the object will appear encapsulated within each drop as an inverted image.

Life on the Surface

Miniature plants that float on water and insects that walk on water offer some intriguing close-ups. Plants are easier to work than animals because, unless the wind is blowing, they do not move around. Try to get the film plane directly overhead so it is parallel with the water. Then it will be easy to achieve uniform focus across the frame, whereas if the back is angled at 45 degrees to the water surface, it will be virtually impossible to get everything in focus.

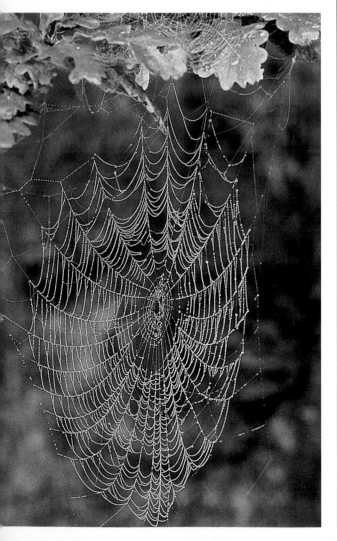

A dew-spangled orb web suspended beneath an oak branch, Herefordshire, UK, October. *Nikon F4, 105mm f/3.5 Micro-Nikkor lens, Kodachrome 200.*

Misty autumn mornings are an excellent time to devote to web photography. Before shooting, I appraise the tonal contrast between the web and the background and use the depth-of-field preview to make sure there are no distracting shapes—including other webs—in the field of view. Once you have selected a web, take care when setting up the tripod not to accidentally knock plant stems, thereby shaking off the dew. Rarely is a web in a position where it is picked out by low-angled sun, but fill flash will add sparkle to the water droplets.

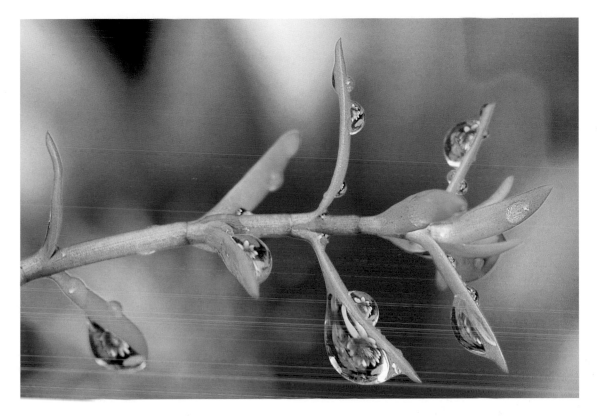

Raindrops on aquatic plant, garden pond, Surrey, UK, August. *Nikon F4, 105mm f/2.8 Micro-Nikkor lens with 1X close-up lens, Ektachrome 100S.*

When you take a critical look at raindrops, they can be seen to function as miniature fish-eye lenses. In this case, an inverted water lily bloom is encapsulated within each drop. However, because the drops do not lie within the same plane and the magnification on the film is greater than life-size, not all of the drops are pin sharp. Nonetheless, it is a fun picture that makes a viewer look twice.

Through-Water Photography

One of the delights of working with small water bodies, such as shallow ponds and rock pools, is seeking out colors and shapes of life below the surface. Before venturing to work on any shore, however, be sure to check the time of low water for your location so you can aim to arrive as the tide is ebbing down the shore, rather than having to constantly shift gear up the shore to avoid its being swamped by an incoming tide.

The surface of any pool is like an imperfect mirror that reflects overhead clouds—or even a crouched photographer. So if possible, walk around a pool, checking for the best camera position without any distracting reflections.

Anyone who has looked down into water wearing Polaroid sunglasses will know just how effective they are for cutting out the surface skylight reflections so that submerged plants and fish become clearly visible. If there is only one safe camera position

125

Freshwater springtails *(Podura aquatica)* on water surface, Surrey, UK, June. *Nikon F3, 105mm f/3.5 Micro-Nikkor lens with additional extension tubes, Kodachrome 25, with twin flash heads.*
For taking this larger-than-life-size image of springtails living on the surface, I transferred them to a small, square, clear Plexiglas tank beneath the camera on a copying stand. This made it easy to get the camera back parallel with the water surface. For maximum definition, I used the slowest slide film available. A pair of flash heads, each angled down at 45 degrees to the surface, froze the incessant motion of the minute organisms.

for taking a pool, use a polarizing filter to remove skylight reflections. For maximum effect, it should be used by holding the camera at an angle of 37 degrees to the water, and not directly overhead. As the filter is rotated, the milky water surface gradually clears to reveal life below. The main disadvantage of using this filter is that it reduces the amount of light reaching the film by as much as one and a half stops, which means that a medium-speed film of ISO 100 or even 200 is obligatory for using a

fast shutter speed to freeze moving animals. An alternative—and cheaper—way of cutting out the skylight reflections on a small area of water is simply to hold an umbrella or a dark anorak over the picture area. This will, however, also reduce the light level.

When photographing emergent frogs, toads, plants, or seaweeds breaking above the surface, a milky skylight reflection can be a distinct advantage, since it helps isolate the aerial part of the subject from

everything else beneath the surface. So on these occasions, I do not use a pola filter.

Wind, which is such a boon for creating abstracts by distorting surface reflections, is anathema for through-water photography close-ups. Ripples can be eliminated from the field of view by using a glass-bottomed box, although it is difficult to maneuver.

On dull days, it may be necessary to use flash to boost the available light, but this may introduce yet another problem—reflection of the flash in the water—unless you move the flash off camera and angle it in about 45 degrees to the water surface. It is a good idea to practice at home on a garden pond or, lacking that, a bowl of water with some plants. It helps to mount the flash on a bar to one side of the camera or have an assistant hold it in position.

Shallow rock pools fringed with seaweeds and inhabited by colorful sea anemones, starfish, and other marine invertebrates are particularly photogenic. The best pools are usually found lower down on the shore, where they are not subjected to such extreme temperature and salinity changes as high-level pools; these rapidly warm up on hot days, and if it rains heavily when the tide

Sea anemone with algae in rock pool, Queen Charlotte Island, Canada, July. *Nikon F4, 105mm Micro-Nikkor lens, Kodachrome 25 with polarizing filter.*

The versatile Benbo tripod was invaluable for positioning the camera exactly where I wanted it for this colorful rock pool cameo. I used a polarizing filter to clear the skylight reflection and thereby increase the color saturation of the rock pool inhabitants.

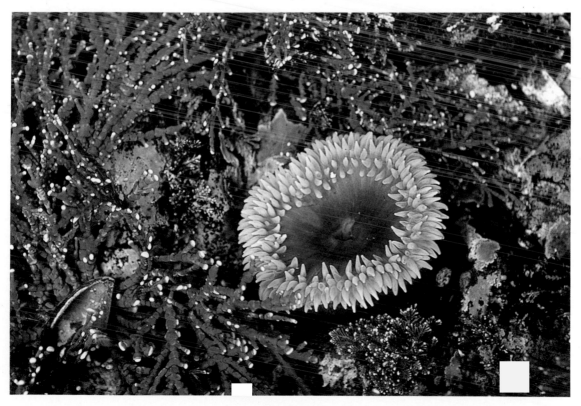

is out, the salinity is diluted. I seek out shallow pools in the middle of the shore without too many seaweeds, which are evenly lit.

Frost Fantasies

Some of the most exquisite frost pictures are to be found as close-ups: A skeletonized leaf, a seed head, moss capsules, or a spider's web all take on a special charm when bedecked with frost, and colored fruits such as wild rose hips or mountain-ash berries lingering on branches, unnoticed by foraging birds or mammals, convey a hint of color through their frosty coatings. Refrain from

Frost on hogweed *(Heracleum sphondylium)* seed head, Surrey, UK, December. *Nikkormat FTN, 105mm Micro-Nikkor f/3.5 lens, Kodachrome 25, flash grazed across the surface.*

Some plants whose flowers are not particularly colorful more than make up with their fruits. Hogweed is one such plant that grows along the roadside. Long after the tiny, white flowers have withered, the seed head persists as a dried umbel much sought after by flower arrangers. When encrusted with frost and grazed with flash along the top, each small umbel glistens like a ring beset with diamonds against the unlit black background.

Clown anemone fish *(Amphiprion clarkii)* at London Zoo aquarium, UK, October. *Hasselblad 500 C/M, 150mm f/4 Sonnar lens with extension tube, Ektachrome 64 with flash.*

 This was one of many shots I took during a commission for a record sleeve. A single flash head positioned overhead simulated sun shining down through the sea. The art director wanted initial Polaroid prints, but as I pointed out, because fish are constantly on the move, I could not guarantee to repeat any shot. We both liked the way shadows from surface ripples danced on the pale backdrop, giving an impression of moving water.

using flash as a main light source to take any frost-encrusted vegetation. More naturalistic pictures will be achieved by using natural light, with possibly a reflector or a flash as a fill to ease light into the shadows.

Aquariums

The structure and color of many small aquatic organisms that live beneath the surface of fresh water or the sea can be appreciated only when seen underwater in aquariums. The techniques for aquarium photography are quite different from *in situ* work. It also enables detailed close-ups to be taken when the weather is unsuitable for outdoor photography or when it is dark outside.

First, check that the front panel of the tank is clean and scratch-free. Wipe away any finger marks using a clean handkerchief. Using a rubber lens hood to prevent any risk of scratching, hold the lens flush with the front panel to eliminate the problem of reflections appearing in the glass. If you have to stand back from the tank, reflections from your hands or pale clothing can be eliminated by attaching a matte black board mask to the front of the lens. To make such a mask, cut a central hole slightly larger than the maximum diameter of the lens. On the back of the board, glue a stepping ring with an outer diameter at least 10mm greater than the diameter of the camera lens. With-

out a black mask, and when hand-holding a camera for greater mobility for taking fast-moving fish, wearing black gloves will prevent reflections of ghostly hands appearing in the front glass.

Sedentary organisms, such as corals, can be taken with quite long exposures using the aquarium lighting, but it helps to have a fast lens. If the tanks are lit by metal halide strip lights, daylight slide film can be used without risk of an unnatural color cast.

Some public aquariums prohibit the use of flash for all or some of their tanks, so check first. If this is the case, fast film will be needed to freeze the action of moving fish; try Fuji MS 100/1000 rated at ISO 1000. Find the brightest area, and wait for the fish to swim into view.

Where flash is allowed, it must be moved off the hot shoe, using an extension lead, or it will reflect back from the tank glass, ruining the shot and resulting in gross underexposure with automatic metering. If you want to be mobile, mount the camera on a flash bracket, sprayed with matte black paint or with any shiny parts masked with matte black tape. Use a long side extension arm so that the flash is supported well to one side of the camera, where it can be angled in at 45 degrees toward the tank. To retain TTL metering, make sure you buy the correct flash sync extension cord.

RESOURCES

Equipment Sources

Bogen Photo Corporation
565 East Crescent Avenue
Ramsey, NJ 07446-0506, USA
Tel: (201) 818-9500
Fax: (201) 818-9177
www.bogenphoto.com
 Bogen, Manfrotto, and Gitzo tripods and also heads.

Cameramac
55 Hodge Bower
Ironbridge, Telford TF8 7QE, England
Tel/Fax: +44 (0)1952 433271
 Custom-made waterproof covers (black or green) for camera complete with telephoto lens.

Cokin S. A. 52
Rue des Solets
Silic 457
94953 Rungis
France
Tel: +331 41734242
Fax: +331 41734240
www.cokin.co.uk/index.htm
 Produces the Cokin creative filter system.

GV Inc.
2050 Executive Drive
Palm Springs, CA 92262, USA
Tel: (760) 323-9575
Fax: (760) 323-9644
 Produces Flare Buster, which shades lens when shooting into the light. Distributed in UK by Teamwork Photographic, telephone +44 (0)171 323 6455.

Kirk Enterprises
4370 East US Hwy. 20
Angola, IN 46703, USA
Tel: (219) 665-3670
Fax: (219) 665-9433
www.kirkphoto.com
 Quick-release plates for all major cameras and their long lenses, Low Pod, Kirk Ball Head, Kirk window mount, and flash brackets. Send for catalog.

A. Laird Photo Accessories
P.O. Box 1250
Red Lodge, MT 59068, USA
Tel: (406) 446-2168
Fax: (406) 446-2513
E-mail: annelairdphoto@twoalpha.net
www.apogeephoto.com/lairdphoto.htm
 Tri-Pad wraps for tripod legs, Laird Rain Hoods.

Lastolite Limited
Unit 8, Vulcan Court
Hermitage Industrial Estate
Coalville, Leicestershire, LE67 3FW, England
Tel: +44 (0)1530 813381
Fax: +44 (0)1530 830408
www.red.net/optex/sales/light/lasto.htm
 Lastolite reflectors and diffusers.

Lee Filters
Central Way, Walworth Industrial Estate
Andover, Hampshire, SP10 5AN, England
Tel: +44 (0)1264 338599
Fax: +44 (0)1264 355058
www.lecfilters.com

Monostat AG
Chilefeldstrasse 17
CH-5634 Merenschwand, Switzerland
Tel: +41 (0)77 645575
Fax: +41 (0)56 6645988
 Monostat monopods with swivel-toe base
(see Photographica entry).

Paterson Group International Limited
Stafford Park 1, Telford
Shropshire, TF3 3BT, England
Tel: +44 (0)1952 423300
Fax: +44 (0)1952 423342
www.paterson-intl.com
 Manufactures Benbo tripods.

Peli Products
23215 Early Avenue
Torrance, CA 90505, USA
Tel: (310) 326-4700
Fax: (310) 326-3311
www.pelican.com
 Watertight Pelican equipment cases.

Photoflex Inc.
333 Encinal Street
Santa Cruz, CA 95060, USA
Tel: (408) 454-9100
Fax: (408) 454-9600
www.photoflex.com
 Diffusers, reflectors, and flash modifiers.

Photographica
45-1548 Richmond Street
London, Ontario N6G 4W7, Canada
Tel: (519) 858-0443
Fax: (519) 858-0449
E-mail: rricher@execulink.com
 Produces MacroPod for low-level photography and distributes Monostat monopods.

Recreational Equipment Inc. (REI)
1700 45th Street East
Sumner, WA 98390, USA
Tel: (253) 891-2500
Fax: (253) 891-2523
www.rei.com
 In addition to outdoor clothing, produces a host of useful items for field photography, including clear vinyl sacks.

Leonard Rue Enterprises
138 Millbrook Road
Blairstown, NJ 07825-9534, USA
Tel: (908) 362-6616,
 (800) 734-2568
Fax: (908) 362-5808
www.rue.com
 A host of useful accessories to aid photography outdoors, including pop-up and portable blinds, gunstock supports, Groofwin support for mounting camera on window of vehicle. Send for catalog.

Saunders Group—A Tiffen Company
21 Jet View Drive
Rochester, NY 14624, USA
Tel: (716) 328-7800
Fax: (716) 328-5078
www.saundersphoto.com
Many photo accessories, including Out-Pack and Photo Backpack; Domke protective wraps, cameras, and lens bags; Stroboframe flash brackets; Polaris exposure meters. Distributes Benbo tripods.

Iain Sinclair New York
21st Floor, 590 Madison Avenue
New York, NY 10022, USA
Tel: (212) 521-4446
Fax: (212) 521-4099
www.iainsinclair.com
Produces Hiplite flashlight. Known as Flashcard in UK, where it is produced by Torch Co. UK Ltd., telephone +44 (0)1223 893363, fax +44 (0)1223 892611.

Tiffen Manufacturing Company
90 Oser Avenue
Hauppauge, NY 11788, USA
Tel: (516) 273-2500
Fax: (516) 273-2557
www.tiffen.com
Tiffen filters and filter kits.

F. J. Westcott Co.
1447 Summit Street
Toledo, OH 43604, USA
Tel: (419) 243-7311
Fax: (419) 243-8401
www.fjwestcott.com
A wide range of lighting accessories, including Apollo, Illuminator reflectors.

Other Photographic Web Sites

Agfa: www.agfaphoto.com

Canon: www.canon.com

Fuji: www.fujifilm.com

Hasselblad: www.hasselblad.com

Ilford Photo Corp.: www.ilford.com

Kodak Co.: www.kodak.com

Minolta: www.minolta.com

Nikon: www.nikon.com

Pentax: www.pentax.com

Polaroid Corp.: www.polaroid.com

Photogenic Location Sources

Photo Traveler Publications
P.O. Box 39912
Los Angeles, CA 90039, USA
Internet: http://phototravel.com
Publishes *Photo Traveler*, a bimonthly information resource of photo opportunities (largely U.S. locations). Back issues available.

Photograph America Newsletter
1333 Monte Maria Avenue
Novato, CA 94947-4604, USA
Tel: (415) 898-3736
Fax: (415) 898-3377
Internet: www.photographamerica.com
Each issue usually features a specific location, giving the best places to photograph and where to find the best wildlife. Back issues available.

Selected Reading and Reference Books

Adams, Kevin. *North Carolina Waterfalls: Where to Find Them, How to Photograph Them*. Winston-Salem, NC: John F. Blair Publishing, 1994.
Locations of more than 200 falls, plus a beauty rating and photo tips for each one, along with color and monochrome photos. This an invaluable guide for anyone planning to visit North Carolina.

Angel, Heather. *Photographing the Natural World*. New York: Sterling Inc., 1994.
A how-to book with tips and hints for photographing the natural world in general, including wetlands.

Angel, Heather. *Outdoor Photography: 101 Tips and Hints*. Rochester, NY: Silver Pixel Press, 1997.
Solutions—many inexpensive—to problems encountered when photographing outdoors in all weather and conditions.

Armstrong, Terence, Brian Roberts, and Charles Swithinbank. *Illustrated Glossary of Snow and Ice*. Cambridge, England: Scott Polar Research Institute, 1973.

Conly, Marc. *Waterfalls of Colorado*. Boulder: Pruett Publishing Company, 1993.
Descriptions of more than 250 waterfalls with access information and a rating for each one are included in this useful guide.

Feibleman, Peter S. *The Bayous of Louisiana*. A volume of *The World's Wild Places*. Amsterdam: Time-Life Books, 1974.

Gilders, Michelle A. *Reflections of a Whale-Watcher*. Bloomington, IN: Indiana University Press, 1995.

Gudmundsson, Ari Trausti, and Ragnar Th. Sigurdsson. *Light on Ice: Glaciers in Iceland*. Reykjavik: Prentsmidjan Oddi hf, 1995.

Gudmundsson, Ari Trausti (text), and Páll Stefansson (photography). *Waterfalls—Poetry in Motion*. Reykjavik: Iceland Review, 1995.

Hautala, Hannu. *Wild Water*. Helsinki: Otava Publishing Company, 1994.
A portfolio of color photographs depicting water and wildlife in wilderness areas of northeast Finland through the seasons.

Jenkinson, Michael. *Wilderness Rivers of America*. New York: Harry N. Abrams, 1981.

Pearce, E. A., and C. G. Smith. *The World Weather Guide*. 2nd ed. London: Hutchinson, 1990.
Gives maximum and minimum monthly temperatures, rainfall, and humidity for 500 locations worldwide.

Plumb, Gregory A. *A Waterfall Lover's Guide to the Pacific Northwest*. Seattle: The Mountaineers Books, 1989.